SPECULATIVE AESTHETICS

RE

RE 001 HYDROPLUTONIC KERNOW
Jake Chapman, Paul Chaney, Iain Hamilton Grant,
Kenna Hernly, Shaun Lewin, Robin Mackay,
Reza Negarestani, James Strongman

RE 002 SECRETS OF CREATION
Conrad Shawcross, Matthew Watkins

RE 003 THE MEDIUM OF CONTINGENCY
Miguel Abreu, Elie Ayache, Scott Lyall, Robin Mackay,
Reza Negarestani, Matthew Poole

RE 004 SPECULATIVE AESTHETICS
Amanda Beech, Ray Brassier, Mark Fisher,
Robin Mackay, Benedict Singleton, Nick Srnicek,
James Trafford, Tom Trevatt, Alex Williams, Ben Woodard

RE 005 WHEN SITE LOST THE PLOT
Paul Chaney, Nick Ferguson, Mark Fisher and Justin Barton,
Dan Fox, John Gerrard, Shaun Lewin, Robin Mackay,
Yves Mettler, Reza Negarestani, Andrea Phillips,
Matthew Poole, Benedict Singleton, Justin Shaffner,
Roman Vasseur, Matthew Watkins

SPECULATIVE AESTHETICS

Edited by

Robin Mackay, Luke Pendrell, James Trafford

URBANOMIC

Published in 2014 by
URBANOMIC MEDIA LTD,
THE OLD LEMONADE FACTORY,
WINDSOR QUARRY,
FALMOUTH TR11 3EX,
UNITED KINGDOM

The roundtable discussion 'Speculative Aesthetics' took place in the Gradidge
room at the Artworkers' Guild, London, on 4 March 2013.
Proceedings of the presentations and subsequent discussions throughout the day
were recorded for transcription and redaction prior to publication.
Publication of this volume was supported by
University for the Creative Arts.

BRITISH LIBRARY CATALOGUING-IN-PUBLICATION DATA

A full catalogue record of this book is available
from the British Library.
ISBN 978-0-9575295-7-1

Type by Norm, Zurich.
Printed and bound in the UK by
TJ International, Padstow

www.urbanomic.com

RE
REDACTIONS

Redaction is the process of preparing source material for publication, implying both recall, distillation, and a settling of accounts (*Redigere*—to bring back, reduce down, call in).

Urbanomic's **REDACTIONS** reprocess live dialogues, rewriting, reconstructing, and reassembling archives of past events.

The original participants are invited to revisit, rethink, and refine their contributions, which are occasionally supplemented by additional resources to further extend the discussion—a montage of collective research in progress.

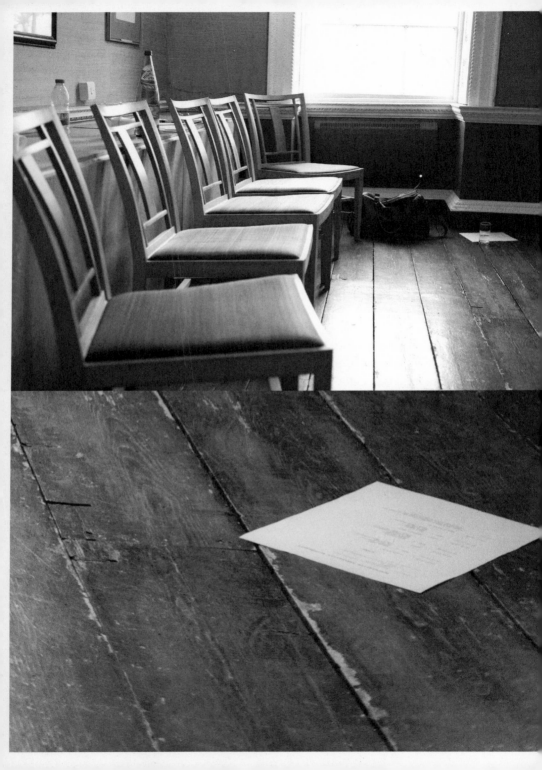

Contents

Introduction 1

SESSION 1
Amanda Beech Art and its 'Science' 9
Benedict Singleton Speculative Design 20
Tom Trevatt The Cosmic Address 26
Discussion 34

SESSION 2
Nick Srnicek Accelerationism—Epistemic, Economic, Political 48
James Trafford Towards a Speculative Rationalism 54
Alex Williams The Politics of Abstraction 62
Ray Brassier Prometheanism and Real Abstraction 72
Discussion 78

SESSION 3
Mark Fisher Practical Eliminativism: Getting Out of the Face, Again 90
Robin Mackay Neo-Thalassa: A Fantasia on a Fantasia 96
Ben Woodard Uncomfortable Aesthetics 106
Discussion 112

Notes on Contributors 121

INTRODUCTION

In contemporary art today a constant reconceptualisation of artistic practice goes hand-in-hand with a perpetual renegotiation of its relation to the affective. The resultant thirst for new approaches has ensured a somewhat hasty appropriation of concepts developed under the (now rather splintered) rubric of 'speculative realism [SR]',[1] to the point where today those concepts have become little more than units of makeshift cultural currency.[2]

Given contemporary art's cultural privileging as the site of negotiation between the conceptual and the sensory, it is understandable that it should have played host to the convergence of SR and aesthetics. Yet such an alliance is puzzling when one considers what SR might bring to this negotiation, in so far as its primary selling point (according to the popularly diffused credo) is its dismissal of the mediating role of human experience. Indeed, if this 'movement' is concerned with wresting attention away from the primacy of intuition and interpretation, it could be (and has been) construed as an anti-aesthetic tendency.

In fact the adoption of SR into art practice and (more prevalently) art discourse has been determined less by an engagement with such concerns than by a series of symptomatic synchronicities. Its endorsement was boosted by the convergence of the anti-correlationist theme with ruminations on climate change and the anthropocene ('a world without us'). Likewise, its concern with nonhuman actants or material complicities speaks to the great inhuman networks within which we know we are enmeshed, but whose complexity artists struggle to figure.

Yet there are also specific and irresistible gains for art here: In its object-oriented guise, where every object whatsoever subsists on the same ontological plane, but simultaneously withdraws from our experience of it, 'SR art' realizes, more economically than the avant-garde's provocations or the social experiments of relational aesthetics, that old dream of levelling the artwork with a non-art universe:

1. On speculative realism, see *Collapse* vol. 2 (Falmouth: Urbanomic, 2007), and 'Speculative Realism' in *Collapse* vol. 3 (Falmouth: Urbanomic, 2008).

2. The most baffling proof of this was 'Speculative Realism's surprise entry at no.81 into *Art Review* magazine's 2013 'Power 100', 'A ranked list of the contemporary artworld's most powerful figures'.

An artwork is simply a thing, in meek and equal existence with other things (fridge; wombat; pen-lid; asteroid; crime-report; proton, etc.). Yet object-orientedness enlivens a retrenchment from expanded practice back to the autonomous object with the thrill of philosophical profundity: in a cosmic reinvigoration of the readymade, any object whatsoever, when supplemented with a faith in the subversive power of objectality as such, becomes not only art but also practical philosophy (multiple juxtaposed objects drawn from disparate fields even more so—what curator would not be invigorated by the notion that the People's Liberation Army is commensurate with a coffee cup?).[3] Following conceptualism's acknowledged failure entirely to collapse aesthetic experience into conceptual proposition, 'SR' makes possible a new 'art after philosophy' in which a vacuously general concept (*object*, *thing*, or *material*) can mysteriously transform any stuff whatsoever into an aesthetically *and philosophically* significant experience. And finally, the promise of a great levelling of the geological and the anthropic, culture and nature, quarks and clerks into one gigantic objectal matrix converges happily with the flat eclecticism of the New Aesthetic and the Post-Internet genera-tion—an endlessly multifarious universe that comes prequantified into discrete and isomorphic tumblr thumbnails. The concepts at work here are loose at best; the aesthetic effects as desultory as the curatorial apologia are extravagant.

In the face of this disappointing (if sociologically intriguing) phenomenon, the first stipulation for a project on 'speculative aesthetics' had to be that it refuse to create further materials for the construction of 'a speculative aesthetic' or to contribute further to the mannerism of 'speculative' art practice. The discussion documented in this volume, which initiated a longer-term project,[4] focused on the structure of the aesthetic component of experience. When the latter is regarded as plastic rather than transcendentally immutable, it suggests a set of definite questions in relation to the philosophical affirmation that cognition grasps a real that is not of its own making, and that its capacities may be reshaped as

3. On 'Object-Oriented Art', see Peter Wolfendale's *Object Oriented Philosophy: The Noumenon's New Clothes* (Falmouth: Urbanomic, 2014), chapter 4.2, where he elaborates on the readymade nature of the object-oriented art object.

4. The Speculative Aesthetics Research Project was initiated in 2013 by Dr. James Trafford and Luke Pendrell for the consideration of open questions regarding the relation between aesthetics (broadly construed), and new forms of realism within post-Continental philosophy (influenced by, though not limited to positions identified with 'Speculative Realism').

a function of that real. The participants in this discussion explore ways in which a study of aesthetics can provide pointers for interrogating the conceptual underpinning of representation, and can furnish materials for an understanding of how experience is structured by various material regimes, from chemistry to digital media; and how these determinations are miscognized in received ideas of the 'aesthetic'. This in turn gives onto the issues that arise from considering the structuring of the aesthetic as an act of political force, and its relation to subjectivation. As far from the idioms of the SR art genre as this may seem, speculative aesthetics here reaffirms a relation between *the aesthetic* and *human creativity*, but within a conceptual framework that refuses to relinquish either of them to ineffability or to immutability. Across the varied contributions to this discussion, aesthetics is both naturalized (it is rooted in that vast 'memory bank' that is the evolutionary history of the species) and denaturalized (the intuitive legitimacy of its spontaneous forms is challenged by synthetic experiences), representation is rehabilitated, abstraction materialized, and cognition accelerated.

But before moving beyond the closed circle of art so as to orient the question of aesthetics in this way, the discussion sets out from an analysis of the stance of the contemporary art genre in relation to the aesthetic—that of a peculiarly ambivalent *aesthesophobia*.

An examination of 'the image' (i.e. aesthetic mediation) and its relation to contemporary art's quest for subversive political potency reveals a contradiction: The image is seen to index a real beyond the shackles of language, beyond temporal politics, beyond established power and frameworks of measure and assessment, and thus in a certain sense free of the constraining forces of the world. Yet despite this faith in the radical potential of aesthetic experience, any actual, particular image—including those that art itself produces—is assumed inevitably to be corrupted by those same forces. Aesthetic experience, incapable of realising its radical potential, can only *gesture* towards it, and must constantly strive to evade determination (or delegate it to the viewer). In the ensuing crisis, contemporary art vigilantly exposes its own compromises with the aesthetic, in an ongoing admission of failure and culpability.

Thus art seeks to discover in the freedom, indistinctness and fluidity of the aesthetic a figure for real freedom beyond politics, yet finds any image that 'works' to be complicit with structures of power. In parallel with certain strains

of SR, it attempts to overcome these established powers of representation by turning to forms of scientificity or literality that would bypass them, undoing the culpable particularity of its images (i.e., their *correlational* complicity with particular forms of representation). It mimics a stance of scientific objectivity in relation to its own methods and forms in order to pursue the chimera of an unmediated (uncorrelated) image—the phantasm of a practice which, finally directly accessing the radical level of aesthetic essence, would be absolutely 'free'.

The parallels between this predicament and SR's central question—How is it possible for thought to access that which is not always-already mediated by thought?—are not coincidental, given the similar institutional contexts within which they emerged. Both parties could possibly benefit from a shared examination of their conceptual and methodological problems, and their sometimes naive appeals to the ruin of mediation and direct access to the real. Unfortunately the story of this entanglement runs otherwise: art discourse and SR discourse have often spurred each other on in the employment of a set of idioms and mannerisms, mediations that *gesture* toward the dark rapture of de-mediation.

The participants in the following discussion are largely concerned with overturning this caricature of a speculative realist thought that seeks to bypass human mediation. Instead they ask how aesthesis, representation, and the image operate *within* the real—without their being, for all that, foundationally constitutive of it. The project of 'undoing the image to undo power' may be futile; but this is not because we must renounce the refusal to hypostatize human experience as the master-category through which the world is to be understood. Rather it is because we cannot simply slough off entrenched constraints in order to access the real that has priority over them. If speculation entails a release of thinking from the constraints of human phenomenality, this does not warrant our positing an absolute breach between the two. For the danger then is that we either return to naive realism, or deliver ourselves to ontological speculation that both occults and doubles its epistemological conceits. Contemporary art's neurosis with regard to the aesthetic may well predispose it to collude in this error.

In reality, then, contemporary art encodes and perpetuates a certain set of propositions regarding the agency of the image. It is a cultural project that deploys aesthetic mediation in a way no less instrumentalised (if more perverse

and obfuscated) than other such projects. This deployment can therefore be considered and evaluated alongside a broader range of aesthetic practices. Such a revocation of contemporary art's privilege in relation to the aesthetic is crucial since the new modes of aesthetically-mediated practices that are bringing about profound changes in the way that we produce, disseminate and consume experience, do so with no regard to that privilege. It is the technological augmentation of the human sensorium, indissociable from the transformation of social forms and the mutation of subjectivity, that places the greatest demands upon a thinking of aesthetics today.

The contemporary structure of representation is the product of an interlocking series of augmented conceptual and sensory frameworks that make the boundaries of our perception transitional and provisional rather than fixed and impermeable. There are manifold new mediations between the human sensorium, the massive planetary media network within which it exists, and the wider universe of which both are minor tributaries. They draw on the advanced resources of scientific and technological abstraction (statistical analysis, mathematical modelling, neuropsychology, big data, etc.); but they are deployed largely in fortifying the comfort (and profitability) of what, following Wilfrid Sellars, we can call the 'manifest image', the inherited, traditional human self-conception. Take for example the aesthetic regime of social media and the response patterns and behaviours it programs at the symbolic-processing and sensori-motor level across whole populations. Aesthetics meets with the sociopolitical in real abstraction, when capital is the precondition for all production and experience at the level of material processes mediated by equally material images. These are abstractions that 'are not in the head but in everyday life'.

It is doubtful whether these aesthetic means of production can be voluntarily redeployed in order that we might interface with this complex system otherwise than as its passive client-producers. Retreat into a localist, anti-technological agenda in the face of complexities and abstractions that irrevocably exceed the compass of individual aesthetic experience is thus an understandable option. But inversely, the prosthetic extension of the human senses is a sine qua non of any engagement with the political reality of a planetary society operating at multiple scales of abstraction. Such realities perhaps cannot be encompassed in anything like 'an experience' in the individual phenomenological sense.

Distilling them into images of complexity figured through a technological sublime yields only an aestheticism that invites passive resignation. A speculative aesthetics may well have to operate in other terms altogether, rethinking aesthetics as a part of an exercise in collective cognition.

A major axis of the discussion emerges here around a Promethean or 'accelerationist' project of the unbinding of imagination, thought, and action oriented toward the enhancement of the human. It understands images as providing new modes of epistemic traction by processing sensory data through symbolic formalisms and technological devices. This is not a flight from a supposed bedrock of concrete immediacy to ideal abstractions, but a progressive reorientation to less localised models—the movement towards a 'universal address' reconsidered as a matter of cognitive navigation, and enabled by aesthetic reconfiguration.

If this suggests a disturbing instrumentalisation of aesthetics, again it should be recalled that a leisurely absorption in images, the rush of the sublime, the staging of a multimedia micro-utopian happening, all possess a certain purposiveness, form part of a project, and mandate certain patterns of behaviour. It is incumbent upon us to assess their effects and effectiveness. If we accept that the emancipatory epistemic function of aesthetic practice lies in its ability to undermine *urdoxa* and to illuminate the socio-cognitive conditioning of experience, it is crucial that this brings with it a commitment to something more than the provocation of moments of alienation or evanescent sentiments of liberation.

This conception breaks with the phantasm of an aesthetic realm that is radically immediate, indeterminate, free of conceptual constraints, or outside all extant power structures; it considers concrete and abstract as relative terms, and the aesthetic and conceptual as inextricably intertwined; and it entails a practice that no longer invests its faith in the essential promise of the aesthetic as such, but instead acknowledges the real force and traction of images, experimentally employing techniques of modelling, formalisation, and presentation so as to simultaneously 'engineer new domains of experience' and map them through a 'reconfigured aesthetics' that is transdisciplinary and indissociable from sociotechnical conditions.

Amanda Beech

Art and its 'Science'

What is art's standard claim to the political? 'Art' is a general term used in con-
temporary culture that, firstly, designates the images it produces as a correlate
of the real, a real that is supposedly free from law and that embodies uncertainty,
contingency and flux. At the same time, this claim to the real is reliant upon the
nature of the images that art produces; upon their occupying a particular space
that manifests the innate and essential character of freedom. On account of this
condition of image-reality, art has come to symbolize an image of freedom from
law, a prepolitical state of infinite and dynamic uncertainty, openness and flux;
yet at the same time, art has tasked itself with the labour of achieving freedom,
in the project of social emancipation.

Two contradictory points follow from these characteristics. The first is that a
certain theory of aesthetic form emerges here, characterized by the claim of the
instability of the image as a condition that appeals to a universal and prelinguistic
experience. This produces an ontology that is tied to a certain epistemology. For
instance, in dialectical critical theory, the alterity of the real, manifest as aesthetic
experience, is mapped onto a potential political project of social freedom. Thus,
ironically, what art is already supposed to possess inherently, it must now achieve
in actuality: it must realize its essence in the given. Secondly, this diagnosis
of art is centred on a moral axis that smacks of both Platonic philosophy and
Judeo-Christian theology: Images are powerful because they are real, slippery
and abstract; images dupe us into believing that the malign forces in our lives
are natural, when in fact they are constructed. But at the same time images are
weak, because they are incapable of achieving emancipation in political terms;
they can only *gesture* towards this potential. *Actual* images are considered to
be disappointingly weak, with no power to effect social change, since the image
abides by the normative systems in which it operates, and in fact it gives rise to
the very malign power that demands critique. This mode of critique rehearses
the standards of dominance that it rails against, since it invests in and invents
the fiction of stable forms of power that it seeks to free itself from. In order to
sustain this critique, art and those systems must be somehow rendered unreal,

called into question as 'mere images', surpassed and destroyed in favour of a more pure form of reality. Once Art is understood as representational and interpretative in a particular modality, it becomes something that supposedly hampers a natural access to the real in itself, since art is never *anything* but always *something*. Which means that images are considered to be weak, but special.

These points connect to the paradigm of difference around which critique is centred, and which produces these contradictions that I'm spelling out: Art is considered to be different from the norm, but it must also *struggle* to be different. On the other hand, art is simultaneously considered *not* to be different from the norm, and must struggle to locate itself in empirical reality as part of the social. It must struggle to normalize itself in particular ways.

As a consequence of these contradictions, art achieved a new self-consciousness. It began to understand itself as being constituted by this dilemma of its own invention, but from which it could not escape. And post-conceptual ironic forms of practice, including Institutional Critique, inform us readily that art is in crisis and will stay in crisis due to its habituation to this critical methodology: Art justifies itself, as art, by reflecting this condition; by giving us the facts about its own materiality and ideals, its own limits and failures. It becomes a knowledge economy, a metacritical reflection upon its own tragedy, and a manifestation of itself as loss.

So one of the elements I want to address today is how art has attempted to escape these dead ends, in part by claiming for itself some sort of science through and with the image.[1] I want to press home how very often this claim towards scientificity has problematically reproduced a self-annihilating culture of art—produced yet another form of self-hatred, based in a resentment of the mediating faculty of the image.

This scientism proposed as a new self-conscious framework has embedded itself as the primary paradigm of artistic critique, as a way in which art in contemporary culture is more than comfortable in defining itself. It can easily be

1. This science is diverse in interpretation and implementation, and includes an appeal to the aesthetics of science in the name of a materialism, often with an ultimate attempt to think past the humanist-inspired role of the author and to overcome the investment in representationalism. Together their mutual destruction would overcome the faith-based assertions and habits of a self-conscious crisis-ridden and/or naive artistic practice that turn out to guarantee the legitimacy of stable and fixed identities.

recognized as the foundational moment of many art practices that are regarded as conceptual or post-conceptual. For example, it was taken up in the false nihilism of BritArt; it swept through the Philistinism of the post-punk world; lapsed into the houses of relational aesthetics; it has been reviewed under the auspices of 'glam' or even a committed reenactment of cultural and political stories; claimed woefully, but with a certain due pleasure, through the games of irony, and harnessed with the new 'edgy cool' in an aesthetics of dispassion, dispossession and cold-war technologies that reoccupy the terrain of the sublime. It has exerted a constraining dominance over art by defining the operations of art in terms of a persistent claim for difference, naively constrained within its own universalizing rule of infinitudinal pluralism, and as such is capable only of an arbitrary commitment to the language that it takes up (its form and matter).

In addition, certain claims towards science have tied together too quickly the moral, the political, and the scientific as the connective tissue of the artwork. Here I mean art practices which, in the name of materialism, turn to method over form: the empirical research project, the phenomenal experience, the 'you just had to be there' moment where artworks turn towards (supposedly) 'unmediated' and pure experience as the measure of art's newfound delivery of the real. Much performance art is testament to this correlation between the real, the unmediated image, and the claim for a politicized practice, as is the employment of the aesthetics of immediacy in documentary-inspired art.[2]

What I'm describing here is the following problem: artistic practice has often sought to embed itself within certain territories that we might call 'scientific' only in a weak sense. It has done this in order to escape the problematic weight of mediation that it carries, so as to better progress towards the achievement of what it thinks of as a more pure form. In order to do so, the work must abstract itself from itself, and achieve freedom from the problematic ideality of representation. It must become invisible. The concept of image-as-mediation now becomes the dominant target of, and the victim of, the mission to undo actual material power—at least this is the poetic claim that is made.

2. For instance, the populism of the observational lens common in video and film artworks ranging from socially-committed documentation of warzones or sites of conflict to the fascination with the computer-generated image in an aesthetics of gaming technologies. In both cases the aesthetics of art enjoys producing a mythological association of technology with alterity, objectivity and neutrality.

An example of this connection to science can be seen in popular artworks that privilege the cult of the processual and the predilection for the temporal. And to me, this is completely illogical. A denial of representation (a kind of invisibility) is correlated with a cumulative gain for an egalitarian concept of visibility in a political sense. Following this logic, if a representational politics is evacuated, then we attain the 'free appearance' of the multitude. This strange correspondence between the annihilation of mediation and the access to the real is as evident in the history of the dematerialization of the artwork of the 6os, as in attempts to privilege the significance of our physical forms of being together, towards life, as in those practices that we saw in 8os and 9os realism.[3]

I would argue that material-based practices and realist practices present two faces of a faith in empiricism that goes unaccounted for in practice. In them we find an interest in the objecthood, temporality, materiality, entropy and lifespan of the artwork shown to us as a set of processes, or as a presentation of its existence as part of the quotidian.[4] On one hand we encounter the idealization of the object made available through phenomenology, on the other hand the idealization of the subject that can depict 'world' as a specific condition. In both cases, Art must turn to the facts of life, to the matter of life, in order to get its business in order and to move beyond the false fictions that are stirred up through and by the image—an image which it associates with the irrational faith of a universal and irrational aesthetics: the bulwark to any science. In order to

3. The historical cultural critique of the dematerialization of the art object into or with 'life' stands as testament to this faith in invisibility. If the artwork can evade its promise of representation then so much the better—it has merged with 'life'. This evasion of representation is also evident in modernist painterly abstraction. However, in both cases, for the artwork to be understood as egalitarian it must claim that it produces an egalitarian experience of a special and abstract language; or vice versa, an ordinary language that is offered as a special experience. In this sense, the equality that is aspired to within the denial of representational form is lost through the framework that presents the experience, as much as the claim that the artwork can achieve the great escape from the modality of its actual material (that is, inorganic) construction.

4. Jean-François Lyotard, 'Answering the Question, What is Postmodernism?', in *The Postmodern Condition: A Report on Knowledge* (Manchester: Manchester University Press, 1984). Lyotard makes the crucial distinction between two forms of art: those of a social realism and those that move towards another form of realism, and into the territory of the sublime. Performative and processual works are set out as the perfect mode of containing and expressing this shift to another alternative register of thought-perception. However, in Lyotard's analysis we return to the same problem of a hierarchical iteration of one form of expression versus another: One form of art that better benefits a theory of the real than another.

deny the false idealising function of art, then, the empirical is advocated as the real path to a more true and more real reality, as if to leave behind the confines of art as category-form.[5]

This kind of attempted escape from art into science is in fact built into art's standard critical method. All of this adds up to a predilection for a certain paradigm of art, and articulates a kind of 'spontaneous philosophy of artists'. Despite the supposed premise of a radical unbinding from the conditions that would constrain the image to specific referents, and despite the claim that art is now free from the dominance of the principle of freedom, in fact this principle is reasserted in new terms, terms that are compliant, conservative, and really unable to see beyond an existing set of conditions that define human agency— precisely because they are obsessed with human agency and its power. So what we can't get our hands on here is a general theory of aesthetics that is capable of expressing reality in such a way that we can consider how images participate in the structure of the real.

We are faced with an art that is defined through its purchase in difference; art's employment of science embodies this difference. Understanding this, we must distinguish this relative notion of difference from the potential for a form of difference that can only be purchased by refusing contingency as a paradigmatic thought for difference. Freedom, in the contexts that I have described, is understood as the nature and the task of art; and this is asserted on the basis of a theoretical connection between image and reality—the notion that these two are innately connected. This is manifested in practice in art's critical method,

5. We can see this move towards life again in the legacy of the Duchampian paradigm, which set out the strategy of the convergence of art and life from the 1920s onwards. Here the institutional borders of galleries and artistic and economic power were called into question by artworks and collapsed, on one hand, as a primary form of critique and on the other hand, in order to live out the claim of art as accessing/being its essential reality. The problem here is that the exact conditions of art's generic paradigm vis-à-vis Duchamp—the principle that art can be anything and therefore must indicate this potentiality of 'the anything'—encouraged all forms of art to proliferate, but the principle itself that supports this system stands strong. Practices that imagined an outside to the system of Art and their ability to occupy this as a real and occupied space quickly rethought their positions and ended up with the status of 'institutional critique'. As such, the game of institutional critique lived out its self-conscious reinforcement of the trap of Art's own mythology. Other approaches to the attack on the concept of art itself deserve more attention here. Work (such as Alan Kaprow's, for example) that sought to 'un-art' the Art paradigm is key, but also demonstrates the problems of the hierarchy of the concept of the *genre* of the generic over the *concept* of the generic that would promise the unbinding of all such relations.

which exhibits its core values. But these methods are in fact false. These methods, in turn, have resulted in a discourse of tragedy and crisis: the figuring of finitude. In other words, they leave art at a loss. The line that has been drawn between the mediated image and the scientific image has exacerbated a form of tragic parlance of the image, and a tragic conception of the political, where the image as artwork is left to narrate its dual constraint: it is constrained both by its task of vigilance and by its own spontaneous nature.

In these terms, we might think of the relation between art and politics in relation to how politics, by necessity, demands the existence of ideology, since it asks for a programme of some kind; and, as in the context of Althusser's *Philosophy Course for Scientists*, how the political demands that the circle of decision produce lines of demarcation.[6] That particular discourse of Althusser's was an attempt to think a form of science and philosophy that couldn't speak of art at all (art was somewhere there on the trash-heap). For me, one of the key problems with Althusser's lectures is that they end up in a sort of figuration, which risks becoming a standard philosophy itself, because philosophical-scientific method cannot avoid a thinking of the image that is connected to its disavowal of consistency and stability. As such, the circle of decision that Althusser draws, and which for him is not a circle at all, but rather the line of demarcation that arcs, is in fact very stable in its reproduction of specific methodological principles that figure philosophy as the stamp of ultimate power. I am interested in the way that philosophy often, despite (and because of) itself, produces a figure—and how, at that precise point, art, or the image, is suddenly invited back in.

This reminds us of the essential and grounding distinction between the recognition of the circle as a practice of power which bears no relation to itself and can never know itself, and the production of the circle as the figure of thought as nature reinstating itself in relation to itself. Here we witness the shift from a practice of non-knowledge to a practice that is thoroughly conscious on

6. 'I entered the necessary circle deliberately. Why? To show even crudely that whilst it is indispensable to leave philosophy in order to understand it, we must guard against the illusion of being able to provide a definition—that is, a knowledge—of philosophy that would be able to radically escape from philosophy or a "meta-philosophy"; one cannot radically escape the circle of philosophy. All objective knowledge of philosophy is in effect at the same time a position within philosophy. [...] There is no objective discourse about philosophy that is not itself philosophical'. L. Althusser, *Philosophy and the Spontaneous Philosophy of the Scientists and Other Essays* (London: Verso, 1990), 73.

the one hand, and yet on the other hand relies upon the immemorial turning of the circle as a ceaseless mark of an inaccessible reality. This is the distinction between the production of lines of demarcation and the repetitive stamp of the circle as a more mystical form.[7]

François Laruelle talks about how no circle is required at all, and as such there is no line of demarcation; and that leads me to ask some other questions that seem unanswered. In *The Concept of Non-Photography*[8] Laruelle says that the circle needn't be entered in the first place: the assumption that we are always already involved in the circle, and that a philosophy needs to work through it in order to overcome it, is just another mark of spontaneous philosophy (and all philosophy is spontaneous). In which case, how the image operates as part of a scientific matrix becomes another question for me, because it means that we must ask how we account for the category of difference—the kind of difference that Laruelle is talking about: a difference that refuses an account of difference, and a concept without difference.

One of the things I should bring up here is that Laruelle makes me wonder whether this idea of a non-differential space of the generic matrix poses some particular threats to art as we know it; whether it is threatening to the paradigm that we know and which I have just outlined.

The question for me is: What is the distinction between the paradigm of art as we know it, and another category of art that we could imagine in this new configuration? I ask this because naming is crucial to politics. And I want to really rethink the question of how we employ the name of art, and what that means when we are producing these things that we call 'art objects'. In Laruelle,

7. P. Macherey, 'Althusser and the Concept of the Spontaneous Philosophy of the Scientists', tr. R. Mackay, *Parrhesia* 6 (2009), 14–27. Macherey's text identifies certain errors implicit in Althusser's critique that cannot be accommodated by Althusser's self-reflexive argument. First Macherey identifies 'an absolute confidence in the impartial mission of philosophy'. He then goes on to articulate a final problem latent in this description of the circle: 'This intervention consists in tracing the lines of demarcation, which in reality only retread the lines already traced, and demand to be retraced again, with no assignable issue, in so far as the conflict of forces that it brings to light cannot emerge as a definitive division that would once and for all isolate all its manifestations. One might see in this approach the index, not so much of a vulgar theoreticism, as of a mystique of the philosophical, which would fundamentally be the last word of Althusserianism, a last word which no "autocritique" would succeed in rescinding' (26).

8. F. Laruelle, *The Concept of Non-Photography* (Falmouth and New York: Urbanomic and Sequence Press, 2010).

I have the feeling that art itself—as a general category—is put at risk: because why bother producing this thing that we call art if the level of science is already achieved, a level where the image is already adequate to the real? Here we can identify two problems: On the one hand, we can say that we are revisiting some sort of pragmatism: we're already doing it, just do what comes naturally.... And, of course, if we just do what comes naturally, well, the risk is that art's 'critical' claim will persist within the same old aesthetic/ethical standards. This non-standard political or scientific moment in itself risks a pragmatic naturalism that would turn a complex refusal of existing structures into an unapologetic and naive affirmation of the status quo and a new ontological normativity. If art already embodies the potential of a non-standard existence, would this not mean that we would be stuck in a semantic game of interpretational formalism: reinterpreting the artwork in novel terms but without altering the principles of its production? On the other hand, what possibility remains for any investment in the category 'Art', and what is produced under its name? Is the generic matrix in the end an intolerant matrix, with its own standards conditional upon the assertion of another naturalism?[9]

I think there are certain risks in the theory that I'm interesting in exploring and which are necessary; and which are also vital in terms of art-making itself, because when I make art, I'm constantly thinking about this: I don't want to make art under the name 'Art' as I know it; but I'm an artist, I'm making art! So what is it that I'm clinging to? That's the personal moral question: What is it that I'm clinging to, when I say I'm an artist? Does it ('art') matter, and how does it matter, and what are the politics of that mattering when we do not invest in a concept of art's causal relation to the political, nor one of its essential relation to the real? This is something I'm working through constantly in my practice, something my practice is constantly questioning: The role of naming, the authority of producing names, the authority that art has in generating force in the name of

9. Problematically for Laruelle, the concept that stands as the truth upon which the image can be unbound from aesthetics, and by which thought can be free from philosophy, risks producing a more basic form of philosophy. This is both despite and due to a 'theoretical autonomy of the visual order' that is, 'a function of the vision-force alone—of the Identity of the real—rather than of the World' (*Concept of Non-Photography*, 76). For it is here that the real remains defined in relation to the image by thought, and non-philosophy cannot give up on its determination of philosophy as the axiom against which it determines its own purchase.

that production, and the way that art cannot apologise for the fact that it is an image, that it mediates, and that it can be a participant in organising and producing power. This returns us to the question of the necessity of the name and its operation within and as another system of power: the name beyond aesthetics.

I think that a lot of these theories that we inherit from art practice very much assume stable and fixed moral identities that are often located within their claims to the invisible, to dispersion and to pluralism. And these theories are where we see the standard moral definition of a liberal arts practice, where 'evil' power is 'over there' and we can just go and work out our critique of it, and art is 'good' and is 'over here'. Extending from this is the guilt-laden critique of art's self-conscious grappling with its own corruption, and its love affair with critiques that would antagonise and brutalise its own set of standards. So that, if art is good, then it must deny itself. Often, as I have tried to demonstrate here today, the way in which it denies itself is by performing this very weak 'science' for which the mediated image is the prime target. In doing so, however, it reinstates both the mysticism of aesthetics as a process, and, along with it, the reification of the subject. This is my problem with art as it stands. For me, to claim art as science is also to claim some sort of demanding power within the political, and this requires a serious investment in a scientific method and a materialism. This is a question of how an artwork might always already inhabit this science, and also a question of how the artwork articulates that crucial and political shift from standard aesthetics to non-standard aesthetics.

The difficulties that art has faced when attempting to do just this compel us to look at how the images that we construct permit and actually promise such a science, rather than offering the thought of the world that we perceive as its correlate. This might not mean asking what images mean, or if it is possible to mean what we say, but rather understanding their persistence in a mechanics of force, as forces that are mobile and institutionally no more 'free' than any other form. To take the image seriously is to understand how images exact force. This is not a modification of art under the name Art, but an interrogation, a traversal, and a leaving behind of the name itself, the name as we know it. This is to understand the power of semblance and to comprehend images as representational action.

An artwork can only effectively participate in such a transformation, then, by participating in an interdisciplinary project of a scientific realism where the force of any concept of art lies in a grasping of relations—what might be understood as a type of montage—that is, direction without ground. This is a leaving behind of the category of the uncategorisable, an unraveling of a politics that requires an order of ontological and non-ontological dimensions, and an overcoming of the fear of representation as a connector to our anxieties of consistency and stability. It is also to understand the image again, as a critical-political project.

Benedict Singleton

Speculative Design

The work I'm going to talk about concerns the ways in which we can and might conceive of *design*. We live in an environment that's densely textured with the products of design, and yet our ideas about design are strangely primitive in comparison. Actually, they're riven with all kinds of unexamined assumptions, historical vagaries and stowaway politics, even when they're presented, as in the better assays in the philosophy of technology, with some sophistication. So I'd like to offer you some ideas about this, beginning with some thoughts about the limits of design, one of which is usually thought to be the extension of its application from nonliving materials to human behaviour.

I started thinking about this back in 2004–5, a point at which a lot of designers began to talk about taking services or organisations as the objects of design. Ideas to this effect had been floated since the early 1990s, and they're still kicking around now, basically unchanged. But this was when they started showing up in the mainstream of design. There was a sense that this was a really *contemporary* thing, the first fresh air since digital interface design. There was much talk about the so-called service or knowledge economy; plus, the message had really sunk in about design historically being the handmaiden of a socially corrosive and environmentally detrimental consumerism. So the possibility of getting away from designing plastic things no one ultimately gave a shit about piqued the interest of a fair few.

We'd been making stuff for services for an awfully long time, but this was supposed to be about more than just putting together a website for a service or designing the seating for a bus. There was a sense that this should be a *collaborative* thing, and that designers should give up their aspirations towards aesthetic dictatorship and work collaboratively with non-designers—people had been rendered 'passive consumers' in the past, to invite them to engage as equals was to liberate them, and this was basically democracy. The people most interested were actually governments like New Labour in the UK who were already obsessed with rethinking public services along more 'participatory' lines,

with 'community' as the response to any given problem. Combined with low budgets and nervous public or third-sector clients, in form and content this actually quite closely mirrored what was happening with relational aesthetics in art at the same time—a tendency to drift towards working with some old people on the plan for a community garden....

I found this basic idea of services and organisations as a medium for design to be much more interesting than what people were making of it. If you took it seriously, you were talking about human behaviour being taken as the object of design—after all, a service, at the bare minimum, involves two people and no artefacts or other conventional design outputs at all, and if you're saying that design can design services.... But what would this mean? After all, lawyers, politicians, economists, psychiatrists and so on all make these normative decisions about how people should act around each other. It is, quite literally, their job. But it's totally taboo for design to do so. People who were actually doing this kind of thing in design—very senior, high profile people in the field—were explicit and insistent that what they were doing should *not* be understood as 'designing behaviour'; but then, without blinking, they'd talk about how important it was for their work to 'encourage' or 'facilitate' certain forms of behaviour. How is this *not* designing behaviour, however subtly? I wanted to understand what was going on here, and a way to explore this, I thought, was to look at a history of *suspicions about designers*, suspicions that they might extend their material palette from wood, bone, stone, metal, cloth, and latterly plastics and pixels, to human beings.

The version of these suspicions that predominates today, as I probably don't need to tell you, is that designing human behaviour is an awful thing to do. It implies 'treating people as things', determining their behaviour from the top down. A really quite abhorrent state of affairs. Now, historically speaking, these are ideas that arrive in the wake of the factory, and in their comparison of people to things, it is factory-things they have in mind. Objects that are interchangeable, generic, anonymous, their behaviour exhaustively prespecified; things that do the same thing again and again, and so on. And while I'm glossing over nuance in the interests of being very compact, it's fair to say that a kind of moral outrage was precipitated by the factory, and the way in which people, in close proximity to machines, had to conform to their operation. I think it is probably quite difficult for us to imagine just how alien an

incursion this was into the landscape of the time, and we're not even talking about a sort of Foucauldian panoptic environment necessarily (although that was part of it); people literally had to conform to the operational dynamics of machines, or lose a finger or an ear to them.

So whether it starts by detailing the exploitation of workers, the technical mindset of seeing the world as a standing reserve, the tight programming of workplace conduct, or whatever, after the advent of the factory comparisons between people and things tend to converge on the demand that the two must be seen as different, with things being obedient servants to people. To refuse this difference would mean that people would have to conform to demands technology places upon them, literally having to act with the gestures and pacing demanded by objects; and that in turn they would end up being 'reduced' to 'mere' machines themselves. In these terms, to objectify is to dehumanize, and it's pretty straightforward to see why 'designing human behaviour' is seen as repellent, especially overcoded by the twentieth century, which added Taylorism and totalitarianism to the mix.

These ideas are surely familiar—they're reiterated endlessly, by Marx, Heidegger, the Frankfurt School, to pick an influential few. The same kind of thing goes way back—the language is almost identical all the way back to the Luddites and various other frame-breakers in the period around the turn of the eighteenth century into the nineteenth. But *not before*. Before the Industrial Revolution, as it turns out, as well as in a lot of non-Western traditions of thought, you get a very different kind of suspicion about the people that today we'd call designers. If the factory replaced something, it was craft work, and that's often still held up as being authentic and wholesome, the work of someone skilled rather than what's practically an automaton, and where it seems that simple tools operate to further what a person wants to do rather than the other way around. This might seem to be a perennial view of craft, but it turns out this is absolute nonsense; it's one hundred percent a product of the factory. What's interesting is that older views of craft enterprise had their own, let's say, pattern of detraction. And even if it's not discussed any more, it's still there in everyday language—in English, in the link between 'craft' and 'being crafty', 'having designs on' someone or something, even simple terms like 'fabrication', meaning both a lie and a process of manipulation; or, for that matter, the idea of being 'manipulative' in itself.

Where does this come from? It's actually a very widespread point of view, one that's emerged seemingly independently in many different places and times but is remarkably consistent across them. To take one example, Plato, in the *Laws*, written about 350 BCE. His remarks on design in that book are contained in a series of passages about how, in the perfect society, people would not be taught to make *traps*. Making a hunting trap would foster in the populace a certain kind of intelligence, one that looks at the environment and sees in it certain tendencies—like an animal's preference for a certain kind of food—and finds roundabout ways of manipulating that tendency. A hunting trap doesn't seek to 'master' the animal, in the sense of physically dominating it in a fair fight, but rather enlists the animal's unwitting help in its own demise. A snare that kills its prey by turning its attempts to escape into the tightening of the noose is an example. In this sense, the trap is the means by which the weak prevail over the strong. It embodies an *insurrectionary* sensibility: 'I can't change this situation myself, but I can construct this kind of mechanism that approaches it in a roundabout way, and gets this to do this, and then this to do this...'.

And the funny thing is, this was immediately associated not just with the creation of traps, but with artifice *in general*. The message here is not solely about design as it turns up in the construction of traps, but that all design *is* the construction of traps. Smithing, weaving, etc., all are about finding ingenious ways of exploiting the behaviour of materials, and that can *include human beings*. In fact it includes an awful lot of very interesting things. The ancient Greeks called the kind of intelligence expressed in the construction of a trap *mêtis*, which labels a certain guileful ingenuity. As a shorthand, it's the intelligence implied when *extraordinary effects are elicited from unpromising materials*. It works with situations that are volatile, slippery, stubborn, or some combination of the three, and it finds ingenious ways to transform their current arrangement into a new one.

If this links design, understood in conventional terms as the production of nonliving artefacts, to situations involving human beings, then it is in the sense of things like plots, conspiracies, *coups d'état*, entrepreneurial success, guerrilla warfare and so on. All of which are things that are usually seen as a *deviation* from 'how the world should be'. The habits of thought we've inherited in the

West have tended to suppress any discussion of things like mêtis—even Plato didn't talk about it, he just said 'this kind of stuff: no'. Instead we've spent a lot of time talking about ends, rather than means; we have a huge intellectual deficit there. Western political theory, as a rule—and obviously I'm glossing here!—has a tendency to couple a description of the present with the elaboration of a desired future, how things are contrasted with how they should be. The bit between, the transition phase, even if it's laid out, is often pretty rudimentary. Even the phrase 'the ends justify the means', the very fact that it's a cliché shows you where the cognitive priority is placed. Mêtis, on the other hand, is the logic of means. It's a general diagram of how to get things done.

It's interesting to draw out the implications of this, which is really a project of speculative design—to think about where this stuff takes us. Certainly it begins to offer some traction on the idea of, say, constructing very new kinds of political platforms. And it connects this to some recent developments in philosophy—like them, it sees the world as an obscure environment, and applies some kind of abductive logic in the form of extreme hypotheses in trying to understand the relation of things to each other. As in Reza Negarestani's work, or the stuff that came out of the CCRU in the 1990s about capitalism as an insurgent artificial intelligence busy constructing itself.[1] If philosophy manifests this kind of geotraumatic worldview that's very much like the work of forensics, establishing the modus operandi of the world by reconstructing the evidence it leaves behind from the crimes it commits, then this speculative design flips it around into a process not of reconstructing plots but of constructing them. Every Holmes needs his Moriarty, after all.

1. See R. Mackay and A. Avanessian (eds.), *#Accelerate: The Accelerationist Reader* (Falmouth and Berlin: Urbanomic/Merve, 2014).

Tom Trevatt

The Cosmic Address

In an unpublished fragment of Robert Smithson's writings on Donald Judd from the late 1960s, the former reveals his antagonism to the latter's 'literal' or 'interesting' art. For Smithson, art was not to be interesting, which always presupposed a human addressee, preserving the personal, anthropocentric sense of authority, but to be 'a cosmos', addressed to the universe rather than only the human. Contra Judd's humanism, which recentred the subject, Smithson held that his work's scientific concerns enabled it to go past the phenomenology embraced by minimalism. I want to propose that Smithson's proposition of a cosmic address can give meaning to an art that does not rely on human subjectivity as a final guarantor.[1] This address, I suggest, proceeds via an ungrounding logic that disarticulates the co-constitution of the world by thought that dominates our contemporary condition as articulated by the Duchampian concept of the art coefficient. The cosmic address is a true atheism. An address that does not locate a God position, but articulates itself towards, and within, a decentred and dispersed immanence constituted by what Reza Negarestani calls a universal continuum.

In the following I want to outline art in the historical conditions inherited from Duchamp, to determine how Smithson's work might offer an alternative axis to this continuum as an immanent given without givenness, and to propose the concept of the cosmic address. To quote Duchamp:

> The gap, representing the inability of the artist to express fully his intention, this
> difference between what he intended to realize and did realize, is the personal

1. Recent critiques of Continental philosophy have named the doxa of human subjectivity as final guarantor 'correlationism'. Theorised predominantly by Quentin Meillassoux in *After Finitude*, tr. R. Brassier (London and New York: Continuum, 2009), correlationism is the dogmatic reliance on occluded fideism in post-Kantian philosophy. Meillassoux embarks on a radical critique of this form of anthropocentric thinking that only thinks the object through its correlation with the subject. Much recent 'speculative' philosophy takes up the task of thinking the object apart from its appearance to a human subject.

'art coefficient' contained in the work. In other words, the personal 'art coefficient' is like an arithmetical relation between the unexpressed but intended and the unintentionally expressed. To avoid a misunderstanding, we must remember that this 'art coefficient' is a personal expression of art *à l'état brut*, that is, still in a raw state, which must be 'refined' as pure sugar from molasses by the spectator.[2]

So for Duchamp, this refining of the work is a performative interpretation, a reflection on the work which co-constitutes it; the spectator completes the work. As he continues, 'the creative act is not performed by the artist alone; the spectator brings the work in contact with the external world by deciphering and interpreting its inner qualification and thus adds his contribution to the creative act'.[3]

This conservative preservation of the subject/object distinction articulated by a reflection produces a dominant subject that activates the 'dumb matter' of the object as though it were distinct from and dominant over it. The project of critique in which art has been complicit relies precisely on this distinction between a human subject and a material object, the organic and the inorganic, or between thought and world. So, the conditions inherited from this project allow art to presuppose a separated and dominant human subject, revealed in the world as a figure distinct from its ground. While art might be able to talk in an abstract language, its interpellating structure is figurative. It figures the human via its address. What we call the Duchampian address is the locating of a work of art for articulation by thought within an interpretive structure. We are built in to the conditions of contemporary art as an external guarantor required for the work to have meaning as such, and in some cases to exist at all. The contemporary condition defines itself precisely via an ahistorical co-positioning that determines the artwork by its concurrency. Art exists in correlation to the human; this correlation whereby art not only exists in temporal proximity to us but is defined as such by that proximity—by being shown, exhibited, put on display or presented for the purposes of interpretation. This co-relation produces us as viewers in a very specific way. *We* are the meaning of art, art is thus addressed to us in a banal circle of finitude determined by terrestrial cognitive limitations.

2. M. Duchamp, 'The Creative Act', in M. Sanouillet and E. Peterson (eds.), *Salt Seller: The Writings of Marcel Duchamp*, (London: Thames & Hudson, 1975), 74.

3. Ibid.

So, it ratifies the dominant subject that capitalizes on the object of the world and reinvests it with a moral superiority, as afforded by the supposed 'ethics' of left-leaning contemporary art. Because such art proposes a privileged relation to the political and critical project, but at the same time undermines that relation by appealing to the subject as the topos of localised meaning production, thus producing a structure of human domination that forecloses the ethical or political via a restricted logic of localism. Following the work of Ray Brassier, we may say that art produces a manifest image of us as dominant that relies on the myth of human figuration over a ground; an image that is in contradistinction to the scientific image. As Brassier points out, the manifest image of man is a 'subtle theoretical construct, a disciplined and critical "refinement or sophistica-tion" of the originary framework in terms of which man first encountered himself as being capable of conceptual thought, in contradistinction to animals that lack this capacity'.[4] This capacity for conceptual thought that founded philosophy, according to Brassier, following Sellars, must be integrated with the scientific image 'such that the language of rational intention would come to enrich scien-tific theory so as to allow the latter to be directly wedded to human purposes'.[5]

Accordingly, art, under the manifest image, mobilizes a conservative concep-tion of the real as bifurcated between subject and object, allowing thought to take a prioritised position in relation to the uncognized/uncognizable object. This bifurcation and preservation of the terms that art performs, provides the ground for a subject to reflect on the work as though thought were distinct from it and yet able to determine that work as such. Art, under the Duchampian condition, acts ideologically to produce forms of subjectivity that reiterate the bifurcation between culture and nature. My aim here is to understand the interpretation of artwork as a part of a universal continuum that stretches through the organic and inorganic, not as separated from or higher than that continuum.

Following Freud, Brassier describes the way a cell membrane is formed to protect the cell from external stimuli:

A primitive organic vesicle (that is, a small bladder, cell, bubble or hollow struc-ture) becomes capable of filtering the continuous and potentially lethal torrent

4. R. Brassier, *Nihil Unbound* (Basingstoke: Palgrave Macmillan, 2007), 3.

5. Ibid.

of external stimuli by sacrificing part of itself in order to erect a protective shield against excessive influxes of excitation. In doing so, it effects a definitive separation between organic interiority and inorganic exteriority.[6]

This he describes as a traumatic cut, a separation of the organic from the inorganic. This negentropic process of self-organisation is described by Brassier as a technology, or *techné*:

> The contention is that the history of technology overlaps with the history of life understood as originary synthesis of *techné* and *physis*. There is no 'natural' realm subsisting in contradistinction to the domain of technological artifice because matter—whether organic or inorganic—already possesses an intrinsic propensity to self-organization.[7]

Thus thought is included as an ongoing negentropic technological self-organisation; thought is immanent to, and not distinct from, material process. For Negarestani, the cut within and by the universal continuum is a way to think local regional horizons as part of the interweaving of the particular and universal. This becomes a 'true to the universe logic [...] synthetic and fully Copernican' that can only be conceived in terms of an 'absolute reflexivity of the universal where the independent relation of the universe to itself takes shape'.[8]

So the relationship between the interpretation of the work of art and the work of art itself is precisely the synthetic binding of thought to the world. In other words, the synthesis between the local interior and the exterior, or universal continuum. To think in this way positions the work of art and the thought of it within a nested traumata of cuts from, and by, the unbound open. For Negarestani, 'trauma is not a rupture marking the centrality or discreteness of the regional subject with regard to its outside, but a regionalizing cut made by a higher universal order in its own continuous field'.[9] This Copernican revolutionary logic thinks a decentred

6. Ibid., 237

7. Ibid., 225.

8. R. Negarestani, 'Globe of Revolution: An Afterthought on Geophilosophical Realism', *Identities* 17 [2008], 17–24: 17).

9. Ibid., 18.

relation between human and world, not the prioritised relation of subjective domi-
nance that sees human capacity as the defining factor governing relations as such.
I would argue that contemporary art, acting through a Ptolemaic counter-
revolutionary mode, rehabilitates us to the trauma of the cut by grounding us in
a subjective distinction from the world, providing the sufficiency of the world
as a ground on which we can stand. But to follow an ungrounding logic true
to the Copernican revolution, we can resituate art within a cosmic region that
'interconnects the particulate, the galactic, the stellar, the chemical, the biologi-
cal, the sociocultural and the neuropsychological within a continuous—albeit
topologically counterintuitive—universal gradient'.[10]

Rather than simply being opposed to the 'human', we should understand this
in relation to the means by which we are bound as 'human' by biological continua.
Thus, far from proposing we abandon the human, as suggested by some reactions
to the expanded field of philosophy to which Gabriel Catren's essay 'Outland
Empire' nominally belongs,[11] I want to pursue a logic of scientific realism that
describes the universal absolute not as an infinite or alternative outside, but
as a continuum of the immanent real that necessarily includes and implicates
the human. Art is yet to adequately address the implications of these demands
from Catren. The ineradicable desire for the new, the expansion of art into
non-art via representation, the figuration of the hero artist from the generic
field, the exoticization of the 'other', the romanticism of the alternative and the
expectation of the bolt of inspiration from the blue are just some examples of
the platitudes by which art progresses. The operation of reflexive analysis that
Catren proposes for the 'different "transcendental" conditions of research'[12] that
can go beyond anthropocentricism, the limitations placed on the experiments
of science by the limits of the human, implicates us in a speculative mode of
thought. A wound has been stitched up by the Kantian conservative revolution.
To perform a dehiscence, we must analyse the conditions under which thought
is performed and speculate beyond those conditions. This dehiscence, Catren

10. Ibid.

11. Reactions to the field of philosophy known as Speculative Realism seem to caricature it as an
abandonment of the human.

12. G. Catren, 'Outland Empire', in L. Bryant, N. Srnicek, G. Harman (eds.), *The Speculative Turn:
Continental Materialism and Realism* (Melbourne: re.press, 2011), 334.

suggests, will finally make philosophy modern: 'Philosophy will finally be modern only if it can sublate the critical moment, crush the Ptolemaic counter-revolution and deepen the narcissistic wounds inflicted by modern science.'[13] From a philosophy synchronous with science, Catren proposes a speculative absolutism that can think beyond the limits of the correlation between human and world that has been transcendentalized in post-Kantian thought. A Copernican revolution must be capable of thinking the absolute, which in Catren's terms comes to mean the real, decorrelated from human access.

Through a decentring logic of true-to-the-universe thought, can we reconceive art's role no longer as that of the production of the fantasy of human dominance, but as that of the furthering of the work of the absolute? Or to put it another way, that of producing a cosmic address that situates itself as part of the nested regional cut within and by the universal continuum? Or to put it still another way, can art partake in a Copernican revolution that shifts the locus of meaning from the local sufficiency of thought to a dispersed and abstracted infinite? In doing so, art would be thrust into 'cosmic exile', a term coined by analytic philosopher Willard Quine to describe an impossible position outside of the limit of human access, but which is taken up by Smithson as a positive project.[14] This exile, or adherence to the cosmic logic of the inhuman, provides us with an asymptotic orientation out of the finitude of human interpretation, radically eviscerating the anthropocentric counter-revolutionary co-relation between thought and artwork. Any escape from the contemporary requires an inhuman material lure, rather than an avant-gardist human hero to lead the way. The trajectory is not mapped by intellection alone, but by a synthetic ecology of hybrid geo-networks that immanently organise. Thus, Smithson's spiral works dislocate a segment of the dizzyingly infinite, becoming, as Thomas Crow points out, 'the sign and imprint of a perpetual tropism, always unfulfilled, towards the "thing itself"'.[15] This segmentation perpetually indexes the infinite spiral from which it is cut, rendering the continuum, rather than the discrete, the object of appreciation.

13. Ibid., 335.

14. As discussed in T. Crow, 'Cosmic Exile', in E. Tsai and C. Butler (eds.), *Robert Smithson* (Berkeley, CA: University of California Press, 2004), 52.

15. Ibid, 54.

Discussion

PETER WOLFENDALE: Amanda, the task you outlined was that of a differentiation of a general notion of art from a twisted conception of art that developed in the twentieth century. And I think that's a very crucial task we need to be focused on: it's a great way of framing a lot of the important issues involved here. It's like an attempt at a thinking of the general concept of art. I'd like to ask your opinion on this, but the intervention I'd bring in is that, in order to think that general concept, we have to get back to an even more general concept, and see art as a species of *beauty*, in a very literal sense. That also means rescuing the concept of beauty from a certain way in which it's been conceived both recently, and throughout history. I think it's important to see it as a very general notion which isn't to be taken as denoting general 'prettiness'. There's an important sense in which the sublime artwork is beautiful. It doesn't have to be pleasant, in that sense, to be beautiful. So, I thought I'd open that up as a potential way of thinking about the dialectic of redefining art.

AMANDA BEECH: Of course, I agree that the question is about the name 'art'; but also, what art constitutes for us is crucial. Especially given that, as I said, all of the definitions of the paradigm of art itself are simply not good enough, or are logically suspect. I think that's where my interest in realism has always come from: for a long time I've been asking these questions, and mainly it comes out of a frustration that art just doesn't seem logical to me! It's made up of certain propositions, and when I test them out, they seem contradictory. I'm not interested in contradictions. I'm very much interested in my work being noncontradictory. Whether I achieve that or not is another thing, but that's what motivates my practice.

Now, the question of what kind of critical framework to use in order to ask what art could be in new terms is a difficult one, because one can easily lapse back into certain Kantian (as well as Duchampian) dynamics. Tom's paper tried to think through the sublime in this way, and I fully understand that—and your example of understanding the sublime in terms of beauty is a strong way out of these problems. This has been captured as a mode of expressing a relation

between the incomprehensible and the irrational as the site of aesthetics; a site that is required also to conjure some universal gestalt of the political. Art, and the issues facing art, were very much committed to questions of the sublime in the late 60s and 70s in terms of how aesthetic experience could correlate with social transformation. Central to this was the work of Lyotard, who associates the processual method of art with a sublime experience that can counter the dominance of social realism and its means-to-an-end allegorising. But as I said, my issue with that is that it resulted in practices, or theories of practices as experience, that attempt to articulate the 'real' as a condition of aesthetics; but that became quickly subsumed back into art's self-reification. The sublime struggles to manifest beyond the fiction of abstract perception and the tradition of an intact subjectivity, held in contradiction. This contradiction preserves politics at the level of private experience and fails to transcend the subject of self-consciousness that 'finds itself' in this experience. I am also unsure of this distinction between aesthetics and unreason, given my interest in the ways in which art is rational.

PW: I agree, but the point was that, rather than see the sublime as an alternative to the beautiful, it has to be incorporated into a more general definition of beauty.

AB: Yes, absolutely, I agree with your attempt to think of a general modality of image-experience. But when we have had theories around that, they've struggled to think the generic nature of the image. I think people struggle with the point at which things are pictured and figured. As soon as the general becomes the specific, things break down. We can go into analytical philosophy and have a kind of systems theory or a language-based theory, of the kind that we encountered in structuralism and as also seen in artworks by Nauman, for instance, that explore the limits of language as infinite, hysterical and tragic repetition. A kind of dead end of language that reinstates the transcendental claim that is conjured in the sublime. Quine writes about the infinite regression that is encountered when one claims an ontology of language, since every claim is also a part of that language that it describes: we see the horror of the infinite before us as a form of the sublime, because there's no way out of this entrapment of the everything and the particular, between reality and appearance and thought and image. I've been trying to think about how we deal with meaning,

in a really simple way, so that we can hold on to the question of the generic and these modes of abstraction that we are dealing with in terms of the concept; that is, how images can operate without a standard aesthetics.

PW: I have this dream that we can reclaim this sense of beauty in which we incorporate all of the ways in which it's historically been figured. I think the theories may seem contradictory, but they are actually talking about different objects or different species of beauty, that are beautiful in their own subtle way. For example, Socrates says beauty is its use. So something is beautiful if it does what it's supposed to do really really well.

AB: But the question of judgement keeps coming back, and we can't seem to escape the production of value. That's the kind of thing I was trying to work through with Laruelle: What happens to concepts of value in thinking equality? How we name something as art, and how we value something as art, and what structures are involved in that; and I think this question of judgement demands more than an archival relation to the beautiful; what might be called appreciation, and this notion of function that you mention. My key concern about the beautiful is its connection to a certain form of passivity.

SIMON O'SULLIVAN: Because art has got a history, it's got a set of problems, a certain pitch to it, it's in a certain arena; you're entering into something that, although it produces problems, also opens up solutions.

My question is for Tom, and it's about the evacuation of the subject. One thing that seems quite apparent to me is that everything was once a subject, and Smithson made that remark—though, of course, he wasn't an artist. And secondly, I feel that the subject/object distinction that you depicted is monolithic—there is this object, and then there is this subject, and this relation is fixed. But the thing about art is that it often pulls something out from the subject, demanding that it transform itself, presuming some sort of mutability of the subject. Indeed, that seems to be one of its achievements. If you just have these fixed categories, you miss all of that. Then, for me, the danger is that a lot of the baby does get thrown out with the bathwater.

TOM TREVATT: I don't think I was eliminating the subject. What I was trying to do was to understand how subjectivity erupts from objectivity, rather than saying, let's just get rid of subjectivity. As Catren says, we can't jump over the shadow of the subject but instead, through a continual deepening of scientific labour, we can seek to locally absolve it from its transcendental limitations. I see this kind of jump occurring within attempts to reach the absolute through the sublime within Romanticism, for example. The vector that I propose at the end is precisely the idea of *not* trying to make that jump. It's not a kind of evacuation, it's an understanding of this continuum that includes the subject as part of it. This plasticity of subject and object you describe is precisely impossible when you think this distinction as definite. I'm suggesting that the Duchampian paradigm relies on a strong distinction between the two, with the final sublation of the object by the subject.

ALEX WILLIAMS: I had a question for you Tom, and it's related to Simon's point. I'm on board with a lot of the theoretical influences you are trying to synthesize, but my question is, why talk about this in terms of *art* anymore? What is art still doing here? I think there is something interesting that art could do here, but I'm not sure where you end up with this. You said you wanted to get rid of the figure-ground element, or introduce something that will problematize it—I understand the resonance of that. But what does the particular 'cut' of art do within this sort of massive cosmic continuum?

TT: I've often asked the same question, why would I care about art? But coming from my position as a curator, I feel the responsibility to unpick this problem that we have inherited *for* art, rather than just saying, this is a problem for philosophy, etc. Let's try to solve this. To answer the question of why I would care about art: because art has a certain capacity; a capacity to produce a type of subjectivity. If my claim is that, currently, art produces a dominant type of subjectivity, can we understand art as harbouring the possibility of producing another type of subjectivity too? This is to question the correlation. The reason why art might be at stake here is that, if it has produced certain types of subjectivity historically, how can we see that playing out in the kind of world in which we live today?

AW: Is there something in the angle you are taking, this kind of 'true-to-the-universe thought', that could offer not just a way of thinking the art that already exists, but could have a prospective element to it, offering normative criteria that could change the way artists make art?

TT: I very much see this as a challenge to, and within, practice. Within my curatorial practice I also see my role as being to challenge artists and art within that sort of relationship.

AB: Going back to Simon's question, I was saying at the end of my talk how important it is for art to be assertive, and not to hide away from its mediating faculty, as I've seen it often do historically and as it still does in its attempt to evacuate itself into the problem of politics and philosophy: Art imagines itself as not being art because it has a hangup about not being useful enough in terms that it can recognise and measure; or because it identifies itself as frivolous or decorative in relation to philosophy, perhaps. What art in this case forgets is that politics and philosophy share these problems. These disciplines are no more free, no more direct, than art. So for me, when I make my work, it's equally important that my work passively destroys all other art, and sets itself up as the art that *should* be called art.

MARK FISHER: I feel that the expectations when entering an art gallery are disappointed as you enter it. As the level of inflation goes up for expectation, the satisfaction decreases greatly. If a Hollywood film was as bad as the level of aesthetic texture that we find in most art galleries these days, you would walk out, you'd be furious, and rightly so! So why bother with the pretence that it's about aesthetic texture at all. It's all about consumerism these days, money. But there has to be this pretence, because it's part of what art is, the context of art. But there have always been tedious arguments about what art is, and we should try to keep it interesting. So why not invest in design, and not art?

TT: That's hard, but I'd go harder than that actually. Not only is art used to money-launder, it provides the conditions under which it's possible for those kinds of subjectivities to exist that want to money-launder. But it's not the only game

on the table, and I think to abandon it somehow says that we've lost that game. The reason I say that the answer to the question is to stay within the game, is to try to change that possibility. If art can take account of the ways it actually produces those types of subjects, then it can possibly change the game.

PW: In my opinion art is all about this excess, and there's this wonderful word from philosophy of value, *supererogation*, which basically means being better than it needs to be. Its value lies in its being beyond what's expected. For me this is an interesting way of thinking about beauty. Design is about producing something that is more than is required. Finding those potentialities that you aren't sure how they are going to be exploited yet, but which open up further possibilities of further action. Which also maximises freedom, to be frank.

BENEDICT SINGLETON: If you look at how the Western concept of 'the artist' took shape in the Renaissance, it was a straight-up hustle. People hyping the importance of things regarded then as craft, like doing paintings, so as to inveigle their way into royal courts and get in with patrons and so on. We should remember that, maybe, when we talk about 'the artist' as that figure appears today—not just that successful contemporary artists are hustlers, which, okay, but that the whole idea of 'art' was hatched as a sort of really great con.

That history aside, I tend to see design and art as continuous to some extent. In any event, I came to design late and knowing nothing about it; I knew nothing about art either; and so I had no conception of a gap between the two fields. I'm more aware of it now, but I ignore it as far as I can. Although needless to say, while design might be appealing in terms of budgets and effecting changes in how people live everyday and so on, it's very difficult to pursue some kinds of ideas—you have to justify what you do to people who, let's say, are interested in achieving what's required according to quite specific goals, and are not much swayed by speculative possibilities.

AB: There's loads of stuff that you said that I totally disagree with, Mark, so I don't know where to begin! Artists go and shoot a video on location, and get to know the locals and they do some anthropology. And then they bring it back and

show it, they go visit an archive, and there's the bit of archive they visited; it's presented as 'here is evidence of all the research that I do'.... I find these to be hideous modes of practice in art. The word 'research' has really made that difficult. But then there's another side to what you were saying which is, to quote Robin, the 'intellectual jewellery' that goes on with art talks—if you're running a public space and you want to add gravitas to some exhibition, you invite certain people to do the talk. No one listens, they're not bothered about what you say, it's just the presence that matters. It's a form of review or validation.

I guess what I'm saying is that there's a whole set of problems going on in the art world and I think it's unfair to say that it's because the art's crap. I go around art studios all the time and there's great art. I also think it's wholly unfair to say that curators are crap. One of the things I really want to try to address is that there is something wrong with the bottom-line nature of the belief systems we go to work with. Somehow there's something wrong with the overall framework, with the way that we actually operate everyday in terms of the structure of 'let's show another black and white video of people suffering—that's political'; and, you know, 'let's have another long drawn-out video because that's how we portray the labour through the lens, which equals politics'. There are certain correlations that are made between image and meaning that have habituated the definition of good art and good politics. I think that these are the responsibility of all of us, but at the same time, they're sort of beyond the modes of the belief systems themselves. They're in it but they also go beyond it.

MF: See, I'm not saying art is crap because artists or curators are; but curators are certainly more interesting than the art they curate. I meet a lot of artists, and I have nothing against them or any artists. But, as interesting as they are, their work is not as great. It seems there is an *obligation* for it to not be that great.

ROBIN MACKAY: Firstly, I would disagree that contemporary art is about aesthetic texture or lack of it. The interplay between the conceptual and the aesthetic is far more complex and diverse across different artists' work. Nevertheless I do agree that the experience on the whole is a disappointing one. Tom, you said that you believe in art because you believe it has the power to transform subjectivity, or to produce new types of subjectivity. But isn't that precisely

one of these articles of faith that Amanda is attacking? The key distinction I would make is between art as a set of institutions, in its social role—whether transformative or merely symptomatic—the increasingly mystifying role that it plays in mediating subjectivity and shaping popular culture, which does indeed have an importance in the production of subjectivity; and the actual encounter with specific artworks, which does vanishingly little in terms of the transformation of subjectivity or even in terms of simple affect. I agree with Mark that the kind of force we are taught to expect from art is entirely absent from the experience of contemporary art shows; it lies elsewhere, in other cultural forms. The institutional logic of contemporary art does indeed have effects, insidious effects, but *not* on the level of that direct aesthetic experience. So what is the link (if any) between the institution of art and the way it produces certain types of subjectivity and a certain type of enthralled audience, and the aesthetic dimension of artworks themselves?

NICK SRNICEK: Ben, hearing your paper, I'm thinking of things like behavioural economics. It's the idea of nudging behaviour slightly and nudging it in the proper direction. There are also things like neuro-marketing. And one of my favourite stories, I think it was a *New York Times* article, is about this young girl who got pregnant, and was buying some stuff online, and the marketers recognised her behavioural patterns and started sending her material for pregnancy, coupons and these sorts of things. Her parents saw these coupons and were pissed off, like 'you're not pregnant, why are the companies sending this to you?'—and then they found out that she actually was! It seems like a lot of modern capitalism is using this as a means to seek profit. My question would be, would you consider design as mêtis to be a weapon of the weak?

BS: Yes, I've used that phrase before. Classically, it's the intelligence at work in hatching courtly intrigues, daring military stratagems, and so on, as much as in the design of artefacts—this is, of course, why it constitutes a link between the design of human behaviour and design more generally, as I said. But what it labels is design as performed within a hostile environment that you can't control directly, it's a way out of being overwhelmed—like pulling a trap

door from the air. The few people who have even mentioned it in the last few decades have totally romanticised it, so it becomes 'the way the little man can stand up for himself against the boss', or something like that. A sort of minor heroism, very humble. Michel de Certeau, for instance, insists that what mêtis wins, it doesn't keep. Where does that come from? How does that follow? It's complete fantasy on his part to think that it's limited to these harmless little ruses, or to identify 'the weak' as the huddled masses. Sure, it's the weapon of the weak, but when you have the board of directors meeting up with marketing to orchestrate a campaign, you're talking about a tiny group of people who are using a technological apparatus to manipulate an entire field of activity to their benefit. They're 'the weak' too.

PW: This idea of mêtis as designing behaviour, and the idea of mêtis as self-manipulation, is quite interesting in the context of Metzingerian positions with regard to the illusion of subjectivity.[1] Self-conception and self-deception: Self-deception isn't a bad thing, it's this really productive thing where we have to deceive ourselves to make ourselves.

BS: Yes. A trap doesn't have to damage anything, it can just...structure the environment, and that fixity can be used, quite literally, for leverage. You might say that one of the most interesting targets to consider trapping is your future self, in order to ensure that you act the way then that, right now, you want yourself to, then.... And this sort of thing is one of the reasons why it's worth resurrecting these old concepts about cunning that no one speaks about these days. At the same time, historically this sort of cunning has been largely characterised as immoral, in all different kinds of cultures, but always for the same kind of reasons. If it's how the weak prevail over the strong, it's totally indifferent to the question of which party is the more sympathetic. And so it's really at odds with any moral project decided in advance. I mean, you conceive of a world that would be good to live in, and then you try to bring it about, but you need to use mêtis to do so, which has its own logic and...you're not going to get the world you want, you're going to

1. See T. Metzinger, *Being No-One: The Self-Model Theory of Subjectivity* (Cambridge, MA: MIT Press, 2004).

get the world mêtis gives you. And its whole logic is that of sedition against established structures, which of course some people may be rather fond of. Its only policy is absolute insubordination against the given, really. Strictly speaking, though, cunning isn't immoral, it's amoral. Amoral not in the sense that people think psychopaths are amoral, because they aren't—they just have a moral compass that diverges profoundly from the norm, one that's highly idiosyncratic and inflexible. It's enormously difficult to imagine what actual, persistent amorality would be like. Something totally alien, I suspect. Like a trickster figure. We don't really have those in the West anymore. Con artists and such, yes, but not really intense and disturbing ones like Coyote.

AW: It's a form of rationality though, so surely it does have a set of norms. It is still a form of practically mediating practice.

BS: Yes, that's true. The question for me is, though, what kind of normative angle does it have? Mêtis yields a sort of aesthetics of 'how to get things done', and the harder a thing is to do, and the more intelligence that goes into it, the 'better' it is. It possesses its own sort of very self-contained dynamic. It sees everything as material that might be recomposed, and there's no kind of limiting mechanism. I mentioned before the trickster, and there are a lot of myths about how a trickster invents the first trap. Usually it's something like: the trickster's hungry, and only has a bit of food, but in this moment of empathy without any sentimentality, he realises that other creatures are hungry as well...so the concept of bait is born. And once the trickster does that for the first time, it's a hairline crack in the order of things that quickly begins to ramify. You can't rise above traps, you can't just say 'I, for one, shall not be trapped'; it doesn't work that way. Being pure of heart makes you predictable, and that's not a good thing here. You're locked into a system where the only way you can avoid being trapped is to engage this world on its terms, i.e. the logic of the trap. The normative schema glimpsed in that escalation is, well, terrifying.

MATTHEW POOLE: What I wanted to ask Tom relates, through Duchamp, to the idea of trapping, to Smithson with the spirals that he makes, and the amorality of it that Benedict mentioned as well. I wanted to ask you, Tom, why you were pitting Duchamp against Smithson, as if Smithson's works reveal greater, more cosmic truths than Duchamp's?

The problem I have is that, firstly, in art-historical terms, Smithson, in his writings and in the 'design' of his artworks, acknowledges the debt to Duchamp many times. Both of their practices as artists and writers are highly allegorical. So it was the allegorism of Duchamp's ironism that Smithson writes about, and this is where I was worried you had slipped a little on the banana skin that Duchamp sometimes puts down, particularly in the writings, which appear to be sober and reflective when they are not—they are highly charged allegorical vectors that are, at the very least, ambivalent. So, when he writes about the coefficient of art, I always consider that to be a trap. It's a highly metaphorical interpretation, which in some ways is impossible. It's an icy ground that he writes on. Duchamp brings you in as a subject in the horizon of the semblance of what might be the constituency of your subjectivity, but at the same time you are brought into it, and you feel that vector of force, of being brought to that horizon.

RM: I was wondering whether you'd say something about Duchamp here, Matthew. It's interesting to make the distinction between design as a distressed practice (as Benedict suggested, necessity as the mother of invention) and art as a practice centred around an axiom of indeterminacy, as Suhail Malik has argued.[2] But it's rather more porous than that, since most design today is *not* produced as the outcome of an urgent situation; and equally, design, like advertising, draws increasingly on the supposedly indeterminate aesthetics and conceptual devices of art.

This led me to thinking about Duchamp and his chess game: what's always insidious and endlessly fascinating about Duchamp is that his work *doesn't* seem to be indeterminate. That is to say, the figure of the game means that

2. S. Malik, *On the Necessity of Art's Exit from Contemporary Art* (Falmouth: Urbanomic, forthcoming 2015).

it doesn't fall squarely within this 'uselessness' that is today understood to form the indeterminate 'space of freedom' of art—even if in a certain sense it inaugurates that space. Duchamp seems to be playing a *game* with you, you actually don't have much choice about your place in it, and you're never sure what it is. But there is a pervasive sense that there is some purpose, even if it's hidden, and indeed cunning.

BS: Most of the stuff that goes on in design studios and engineering labs around the world is, in a way, less creative than recreative, or at least it's concerned with minor modifications to what exists performed in a pretty stable environment. Mêtis is present there, but not, as it were, in full flight. Which is not to say that it has to announce itself loudly or be dramatic. Necessity is the mother of invention, as the cliché goes—yes, but an assault on a constraint that is perceived as 'necessary' doesn't have to be done under the gun in any sort of overt way. Getting out of Earth's gravity, for instance: Nikolai Tsiolkovski a hundred or so years ago designs the multistage booster rocket, which works by successively jettisoning stages as it ascends, when the fuel in each is gone. This allows the final stage to achieve escape velocity far more easily than the whole thing could, but it goes against every intuitive engineering principle—seriously, the thing falls to bits in the air, it doesn't sound so promising, does it? But it's incredibly ingenious, and the process of putting together the designs was a quiet one involving a lot of thought, not a spectacular improvisation. Anyway, as to purpose, I think launch technology is actually a good example of design exceeding a specific purpose; we don't have to go to space, we got by fine without it…. But you do it precisely because it explodes the possibilities of what we might do next; that's the central contention of what has been called Cosmism, the philosophical school of thought that insists on just this principle in regard to going to space.

AB: But isn't one of the key distinctions between art and design, as we have been discussing here, that it's about purposiveness? Although art enjoys its crisis so much, it also enjoys the self-conscious knowledge of its own limitations. There's an almost smug claim there. So it's not about art having a lack of purpose; what we are discussing are just *different* purposes. Maybe we need to

be more clear about that: my whole problem here was the fact that art certainly *does* have a purpose, but it's simply not the right one!

BS: Certainly there's a degree of continuity between art and design. A lot of senior design people, who basically get to set their own briefs, have the creative autonomy one might typically associate with artists—though they might not be seen as good ones—and on the other hand, you could say that art is a subcategory of design. I mean, it might be tricky to argue when you get into the details...but it's viable to suggest that art is a form of design that aims to have a function in a very particular environment, a space bracketed from 'everyday' encounters with objects, in the form of the gallery. When you take art out of a place specific to presenting it, it has to contend with all the design that's already out there. I'm biased, of course, but I find it faintly monstrous that it's socially acceptable to put so much concerted creative labour into things that are bound for a gallery, yet so little goes into so much that's outside. It feels... not modern, to me.

AB: If you think about the rise of 'the curatorial' over the last twenty-five years (I know it's been going on for longer than that, but especially in the last quarter century), just as we have all these names for curators—organisers, facilitators, etc.—'designer' is also an easy word to use: there are BAs now in 'Designing Life Experiences', which are basically curating BAs; you have 'Experience Design' and stuff like that, but it's a form of curatorial design. In the sense of the whole organisational turn in art which moves towards choreographing experiences, and which came out of the happenings of the 60s, I would see the curatorial as being evidence of the collapse of art and design.

BS: Or the collapse of art into events management!

	S		High	Low	st Chg
	14		23.00	23.00	10 +0.05
.4	23		30.40	30.19	5 +0.05
...	dd		1.20	1.05	0 −0.10
...	dd		0.96	0.78	6 +0.01
...	dd	1	1.54	1.40	5 −0.14
...	dd	1	1.46	1.46	6
.5	15		0.98	29.48	0 +0.76
...	30	8	8.02	7.70	6 +0.18
...	dd	37	1.30	1.20	3 −0.04
...	dd	11	0.92	0.87	7 −0.02
...	dd	2	4.17	4.01	1 +0.04
...	dd	2	1.79	1.60	4 −0.15
...	dd	2	1.53	0.49	3 +0.03
5.8	...	1	30	15.13	7 −0.16
		1	49	2.40	7 −0.01

W

	14	63	20	15.27	0 +0.49
2.9	20	35	85	27.20	5 +0.05
	12	51	59	21.15	6 −0.09
...	dd	15	05	0.98	8 −0.10
2	...	57	11	33.70	2 −0.15
7	10	369	70	26.11	0 +0.21
0	10	3	15	15.85	3
	19	78	4	15.63	3
	14	2	7	25.56	3 −0.04
	9	2	4	58.24	1 +0.19
	11	6	5	13.51	5 +0.15
	15	2083	3	22.50	−0.06
	15	75	0	20.26)
	22	2171	3	34.52	+0.24
	d	458		5.04	5 +0.01
	d	138		1.57	+0.04
		48		36.52	+0.01
	1	1076		17.40	−0.14
		7627		5.68	−0.20
		2168		14.14	−0.33
		5156		6.67	−0.31
		3469	1	15.50	−0.73
		2310	3	34.07	−0.27
		53	2	20.00	−0.05
		477	1	18.94	−0.40
		71	2	24.15	−0.78
		2	3	35.07	+0.19
		15	1	14.78	−0.02
		45	1	15.74	+0.04
		37	1	4.71	+0.14
		8	34	4.56	+0.01
		4	12	2.45	−0.19
		3	41	0.73	−0.58
			2	2.55	−0.10
			1	1.24	−0.06
			3	3.30	−0.30
			1	1.30	+0.06
		20		0.25	+0.09
		35		0.25	+0.90

Nick Srnicek

Accelerationism—Epistemic, Economic, Political

In recent discussions, 'accelerationism' has arisen as an expression which purports to unify a wide swathe of seemingly disparate movements under its referential gesture: from ultramodern epistemology to Promethean dreams to cosmist utopianism to post-capitalist economic organising.[1] My aim is to try to highlight some of the connections between these tendencies, in particular emphasising a subtle distinction between epistemic accelerationism and political acceleration-ism. The former indexes an approach to knowledge that involves expanding the scope of knowledge, synthesising disparate fields through creative bridging constructions, and ramifying the space of reasons. It is enlightenment principles of critique and rationality shorn from their contingent humanistic basis. Political accelerationism, on the other hand, indexes a postcapitalist order whereby the limitations of the current accumulative logics are torn down and the productive potentials of society unleashed. This paper will, firstly, examine some speculative thoughts about the relationship between these two accelerationisms. Secondly, it will attempt an initial answer to the question: What does accelerationism reference in the context of politics? And finally, it will present some thoughts on how technological models and aesthetics can facilitate this accelerationism.

We start with this question of accelerationism, and the question is: What exactly is the common basis for all of this—is there a common basis, is there any meaningful sense to this term 'accelerationism'? My own interest was in the politi-cal aspect of it all, whereas it seems that, for instance, Reza Negarestani's interest is primarily in the epistemic aspects. And it eventually became clear that there were two ideas of accelerationism here: epistemic acceleration, which involves broadening knowledge and synthesizing all these different fields; and political accelerationism, which essentially is the use of certain technologies and social organisations in order to augment your own capacities, and that sort of thing.

1. See Mackay and Avanessian (eds.), *#Accelerate*.

And then it was either Benedict [Singleton] or Pete [Wolfendale] who high-lighted that *freedom* is the fundamental commonality of all these forms of accelerationism. On the epistemic side, freedom must be contrasted with any naturalized or immanent vision of freedom stemming from some unique attribute of the human condition. Freedom instead is the binding of oneself to a rational rule and an adherence to it. And then, on the political side, you have the use of these technologies and these framing elements of social, political, and economic institutions that make possible the implementation of such freedom. The overall accelerationist aim must therefore be designated as, in Benedict's words, a 'generalised escapology'[2]—an unrelenting project to unbind the neces-sities of this world and to transform them into materials for further constructing freedom, media for accelerating human beings beyond current limitations.

I want to try to think about these things by tying together epistemic accelerationism and political accelerationism, and by then taking some tentative steps to try to filter this through, particularly, economic knowledge as it exists nowadays. So primarily in terms of neoclassical economic modelling—the sort of stuff the IMF and the World Bank use in order to understand exactly how economic policies are going to interact in and with the world.

The epistemic critiques of these things can actually lead to an argu-ment for something like postcapitalism. Two examples: one is that at the foundation of this sort of neoclassical economics there is an idea of equi-librium. The idea that between supply and demand there is a certain set of points, a certain set of prices, that would allow an equilibrium to be attained. This is the foundation of neoclassical modelling. Now the problem is that, essentially, when people in 1954 proved this theorem—that there was this equilibrium—they never made any argument for how an economy would actually get to this equilibrium point. They just assumed that such a possibility exists, and that therefore every economy must orient itself towards it.

Today we understand that you have to take into account disequilibrium economics—the idea that the economy doesn't necessarily tend towards equi-librium, that instead it can have positive feedback loops and other sorts of things that result in wild fluctuations. The idea is that once you take disequilibrium into account, you then have to have some sort of governing hand that modulates

2. See B. Singleton, 'Maximum Jailbreak', in Mackay and Avanessian (eds.), *#Accelerate*.

the economy, and that turns it away from a neoliberal free-market economy. So I think that in one sense, epistemic accelerationism, the epistemic critique of these economic models, actually leads to an argument for something like postcapitalism. If one gives up on the myth of equilibrium, the question shifts away from producing a 'natural' market and towards the problem of how best to plan an economy.

Second example: one of the foundational arguments for capitalism put forth in the 1930s by Friedrich Hayek concerned the socialist calculation debate. This is the idea that the market functions best as an information processing machine—this is what it does best, and the price system is a means of transferring information efficiently effectively and quickly throughout the entire economy. And Hayek's and von Mises's argument was that socialist planned economies can't do this; instead, they have to route their information into a centralized bureaucracy, where the bureaucrats decide how to set supply and demand, and then send it out to the factories. The argument was that such socialist calculation was irrevocably less efficient (slower and more wasteful) than the calculations carried out in decentralized fashion by the market. This is one of the foundational arguments for capitalism. And I think Hayek was actually right in the 1930s—we just didn't have the capacities to beat the market as an information system. But what's interesting now is that we do have a certain number of technologies that *would* allow us to beat the market at certain games.

And so now you can turn Hayek's argument on its head and make an argument for something like a planned economy (as in Paul Cockshott's work) or some sort of decentralized planning (as in the Cybersyn example).[3] So in these two cases, I think, epistemic accelerationism can facilitate the shift to a sort of political accelerationism. And then the final element is the notion of freedom as binding yourself to a rational norm, and understanding this in terms of an augmentation and expansion of our capacities for action. From these two aspects you can start to understand a shift to something that is beyond capitalism, and to think about it in terms of freedom.

One traditional argument is that freedom is freedom from work—which is implicit in Marx's idea that in the morning you're doing one thing, in the afternoon

3. See P. Cockshott and A. Cottrell, *Towards a New Socialism*, http://ricardo.ecn.wfu.edu/~cottrell/socialism_book/new_socialism.pdf; and on Cybersyn, http://www.cybersyn.cl/.

you're doing another thing, and at night you're doing another, and that most of it is leisure—there is very little work in the sort of communist society Marx presents. I think this is right—freedom from work should be one of the primary demands of the postcapital society. But this is a thin idea of freedom, freedom simply as the absence of constraint. I think the more substantial notion of freedom is essentially, to put it in Nicolai Fedorov's terms, that of having a 'common task' for humanity, something you can actually build that conscientiously works towards expanding our capacities—whether it be space colonization as in Fedorov's proposal or some other grand collective project.[4] So I think this adds some content to the idea of what a postcapital society might mean, beyond just traditional Marxist notions—namely that it would also involve common tasks.

What role, then, for aesthetics in such a project? Aesthetics here indexes one of the primary problems of epistemic and political accelerationism: how to transform a computational sublime, a data sublime, into forms that are amenable to our limited simian brains. How, in other words, do we transform something like a complex economic model into a tool for the manipulation of economies? Aesthetics, in such a project, is about design as a means of manipulation, rather than about beauty. It is about translating the technical sublime—a banal feeling of wonder at complexity—into effective tools for navigation and transformation.

Too often, cognitive mapping in the aesthetic field does not go beyond the level of the technical sublime—mapping out intimate and detailed connections between leaders, money, power, classes, and financial interests. While pleasing in the sense of beauty, these cognitive maps typically reproduce all the problems of global capitalism's complexity. Various attempts to transform global finance into an aesthetic form often fall foul of this, mapping financial networks in exquisite detail but offering no practical leverage for altering the financial world. An opposite problem arises in the tendency for all data visualizations to embody the same banal aesthetic of the network diagram. In this case, a minor sense of beauty is mixed with a minor sense of cognitive tractability, while the heterogeneity of the world becomes lost in the nodes and edges of social network analysis.

4. See N. Federov, 'The Common Task', and B. Singleton, 'Maximum Jailbreak', in Mackay and Avanessian (eds.), *#Accelerate*.

The new modelling software *Minsky* illustrates one path towards this attempt to visually mediate between complexity and accessibility.[5] Rather than rely on programming knowledge, *Minsky* operates via visualizations of the economy (in particular, the monetary system). It not only makes economic modelling more readily accessible, it also provides tools for easily manipulating it. The entire model is scalable, from detailed representations of agents to large models of monetary systems. While still requiring some mathematical and computing literacy in order to fully construct models, these tools allow users to experiment and develop them in ways that go beyond the traditional models of economics. They can provide some of the cognitive technologies which will allow for a detailed critique of the existing system (on its own terms), a navigational medium for making intelligible the dynamics of global capitalism, and lastly, a basis for beginning to think through what a postcapitalist, postsoviet economic order might look like.

So this is one thing that can help out in the current conjuncture: economic models which adopt the programme of epistemic accelerationism, which reduce the complexity of the world into aesthetic representations, which offer pragmatic purchase on manipulating the world, and which are all oriented toward the political accelerationist goals of building and expanding rational freedom. These can provide both navigational tools for the current world, and representational tools for a future world.

5. See http://sourceforge.net/projects/minsky/.

James Trafford

Towards a Speculative Rationality

What I want to discuss today is a fairly nascent strand of thought (which I develop in more detail elsewhere) that attempts to understand the generative possibilities of the quasi-transcendental structure of norms. In this sense, what I'm doing is related to aesthetics in the very broad sense of outlining a kind of 'rationalist creativity' that abjures the need to posit spurious metaphysical categories, and so helps us to understand the problematic relation between 'speculative realism' (whatever that means now) and metaphysics.

Pinning down precisely what it is to be 'speculative' is a tricky gambit that is fraught with the danger of rerouting thinking into metaphor-based metaphysics. However it seems that at the heart of the speculative project is an attempt to release thought from a secure relation with the earth and the structure of human representation. In this respect, speculation entails a release of thinking from the constraints of human phenomenality, but without thereby also warranting a breach between the two.

Broadly speaking, then, we have the twofold suggestion that conceivability does not straightforwardly entail possibility, and that humans have no privileged access to reality. But this sort of move towards a kind of dissolution or at least displacement of the epistemic role of human experience and thinking, seems to render any project relating to aesthetics difficult, to say the least. Whilst human experience may not have any privileged access to reality, we still, by necessity, begin from within its strictures. So it is important to figure out exactly what those strictures are, and then to understand their potential manipulability. In part, I take it that a great deal of the tendency toward speculations regarding weird realism and eldritch objects owes to an impatience regarding this fact. But there is no easy formula for the sloughing off of human conception and the 'manifest image' of the world. Indeed, in forgetting this, we run the risk of simply smuggling extant intuitions and beliefs into ontological categories.

When we look at these intuitions, beliefs, and so on, what is striking about the research in cognitive science over the past fifty years or so is the identification

of human *doxastic conservatism.*[1] Here the study of human reasoning has led to a pretty solid eradication of Piaget's paradigm according to which reasoning, broadly speaking, follows the rules of classical logic. The experimental psychology of human reasoning suggests that humans have a fundamental bias in 'the tendency to automatically bring prior knowledge to bear when solving problems'.[2] In the literature around this, it is often suggested that most reasoning revolves around what is called 'representative heuristics' judgment, which results in a fundamental 'belief bias' across human reasoning. So, it looks like humans have a tendency towards doxastic conservatism, in that we routinely seek to confirm our existent beliefs (even when they lead to 'incorrect' reasoning measured against, for example, classical probability and so on).

This makes sense if we think that a lot of cognition is (at least to an extent) driven by heuristics and connections at some sort of level of representation matching, associations, and so on. More interesting though, in relation to philosophical methodology, is the question of whether or not philosophy solidifies this human disposition towards doxastic conservatism (through an appeal to intuitions, etc.). In much of philosophy, our theories are judged by a set of criteria that certainly includes their intuitive pull, and are often decried where they are 'counterintuitive'. But if this were the sole criterion then philosophy would be stuck within the structure of the manifest image of the world, formatting reality for the human subject. I'm not suggesting that this is bound to be the case, and surely this is the starting point for much of the impetus behind speculative realism. But I think what's important is that our speculation cannot just 'leap free' of where we are because we run the risk of producing empirically overdetermined ontologies that are ultimately conditioned by our intuitions and associative tendencies. Our intuitive beliefs and semantic associations, as expressed in natural languages, have no cognitive authority; but this does not preclude mechanisms that revise and extend that language, starting from such inchoate beginnings.

1. See the work of C. Dutilh Novaes, e.g. *Formal Languages in Logic: A Philosophical and Cognitive Analysis*, (Cambridge: Cambridge University Press, 2012).

2. See K. Stanovich, *What Intelligence Tests Miss: The Psychology of Rational Thought* (New Haven, CT: Yale University Press). This is seen in matching biases (P. Wason and J. Evans, 'Dual Processes in Reasoning', *Cognition* 3:2 [1975], 141–54); and deductive biases (D. Kahneman and A. Tversky, 'The Psychology of Preferences', *Scientific American* 246 [1982], 160–73). The latter are exemplified by the now infamous 'Linda problem' (Ibid.).

My suggestion here is that we can utilise the development of formal languages in mathematics and logic to provide mechanisms by which we might radically revise the 'manifest image' precisely because of their immanent ability to 'suspend' the world.

However, this is a feature of formal language that has often been misunderstood. Meillassoux, for example, argues that the structural nature of formal logic and mathematics furnishes his position in two ways. Firstly, they provide a way of suspending natural language semantics by operating only with 'meaningless signs' (in the sense, presumably, that they are not interpreted by a world external to that language).[3] Secondly, according to Meillassoux, this structure supposedly allows access to a reality independent of thought. In this regard, Meillassoux looks to sit staunchly in the fairly traditional formalist project developed by Frege and Hilbert. The origins of this project lie in the treatment of formal language as an expressive resource, seeking an *ex ante* rigour. On this view, formalization is a process of 'making-perspicuous'—of clearing-up and clarification. Given this '[m]echanical nature of formal transformation',[4] the received view is that 'there can never be surprises in logic'.[5]

I think that this picture is largely (though not entirely) incorrect. I agree with Meillassoux's first suggestion that formal languages need not make explicit semantic relationships in interpreted structures—this is to think of them in terms of pure syntax. We can understand this as a procedurality and operativity, which we can think of in terms of a process of 'de-semantification'.[6] This way of understanding the role of formal language allows for a 'suspension of the world' as encoded in representational structures. Importantly, in contrast to the traditional view of formalism, this also means that a formal language doesn't merely function as an expressive device. It also provides a mechanism by which

3. Q. Meillassoux, 'Iteration, Reiteration, Repetition: A Speculative Analysis of the Meaningless Sign', in A. Avanessian and S Malik (eds.), *Genealogies of Speculation: Materialism and Subjectivity Since Structuralism*, (London: Bloomsbury, forthcoming).

4. L. Wittgenstein, *Tractatus* 6.126.

5. Ibid., 6.1251.

6. S. Krämer, 'Writing, Notational Iconicity, Calculus: On Writing as a Cultural Technique', in *Modern Languages Notes* 118:3 (2003), further developed in Dutilh Novaes, *Formal Languages*. 'A fissure of "operation" and "construction" on the one hand, and "interpretation" and "understanding" on the other, is positioned in such a way that the specifically mechanical, technical aspects of the symbolic cultural practices emerge' (Krämer 2003, 531).

syntactical structures can be manipulated in order to reason and construct theories without the constraints of representation.[7] Put like this, we can accept that formal languages concern the mechanical manipulation of signs without interpretation, while keeping open the notion that such mechanisms may also be creative or generative in some sense.

It's important, though, that we don't see the developments of formalisms in terms of either a mere 'game of signs', or as just modelling actual language use, behaviours, and so on. If we think about this in terms of the rules of logic, for example, there is a perennial attempt to try to justify sets of inference rules (usually in natural deduction form), through an appeal to an underlying set of behavioural dispositions, and so on, with expressions of natural language. But if, for example, first-order classical logic is meant to model natural language use (or a fragment thereof), it is difficult to see how this modelling process is going to work, given the massive discrepancies between model and reality. For example, the inferential patterns associated with a logical expression often operate through 'quick and dirty' heuristics and associations, where thinkers may rely upon a variety of psychological phenomena such as preferences, emotions, desires and so on. We cannot simply 'read off' and model the rules of logic from the actual use of natural language terms, since there is nothing there substantive enough to determine the correct interpretation within that model.

In this sense, we ought to see that such intuitions are, at best, prima facie; and moreover, that they are plastic. This is why it has been possible to develop an understanding of alternative logical systems which run against certain deeply held intuitions structured within our representational architecture. The way in which logics develop is not a matter of 'reading off' rules of inference from manifest-image reasoning processes. Rather, logics are developed within a mixture of formal and informal reasoning processes, with informal reasoning always a moving target. What we have in formal languages, according to the view proposed here at least, is a machine by which our intuitions can be suppressed, and logics can be formulated and discovered.

7. 'The rules of calculus apply exclusively to the syntactic shape of written signs, not to their meaning: thus one can calculate with the sign "0" long before it has been decided if its object of reference, the zero, is a number, in other words, before an interpretation for the numeral "0"— the cardinal number of empty sets—has been found that is mathematically consistent.' (Krämer, 'Writing, Notational Iconicity, Calculus', 532).

In this sense, the construction of the formal rules of a logic will neither describe how human agents actually reason, nor how we think we should reason, and so will be necessarily procrustean. But, in this sense, the development of a set of inference rules defining the behaviour of a logical connective can be understood as part of the process by which ordinary reasoning is emended, rather than merely described. This way of putting things meshes nicely with Sellars's construal of the inferential rules as 'rules of criticising' rather than 'rules of doing'.[8] On this view, a set of inference rules are taken to constitute normative (mutable) constraints upon agents' actual practice. Then, through the explication of the meaning of a logical expression utilising formal methods, it becomes possible to emend (and perhaps even replace) the unclear patterns of behaviour with those expressions in natural language. In other words, there will inevitably occur an interplay between the construction of a set of formal rules that we take our practice to be governed by, and a process of emendation and explication of that practice. This is immensely useful since certain features of ordinary practice will inevitably be revised and the resources of our ordinary language expanded in their construction. By upturning the ground of reason in transparent introspective accessibility through its necessary exteriorization in the nonintuitive mobility of formal languages, it then becomes possible to consider multiple modes of navigation across the normative structures of reason.

In general then, I suggest that a more profitable way of characterising the relationship between languages is to understand formal language as a kind of quasi-transcendental machine that both operates upon natural language, and provides a mode of creative reasoning that is possible only by way of a necessary suspension of the world. This position is close to that developed by the second-wave externalist conception of the technology of language. Language, for one of the originators of this position, Andy Clark, is the ultimate artefact, evolving in symbiosis with human cognition: 'language as a computational transformer that allows pattern-completing brains to tackle otherwise intractable classes of cognitive problems'.[9] In contrast to an internal 'language of thought', Clark asserts

8. W. Sellars, 'Empiricism and the Philosophy of Mind', in H. Feigl and M. Scriven (eds.), *Minnesota Studies in The Philosophy of Science, Vol. I: The Foundations of Science and the Concepts of Psychology and Psychoanalysis* (Minneapolis, MN: University of Minnesota Press, 1956), 253–329.

9. A. Clark, *Being There: Putting Brain, Body, and World Together Again* (Cambridge, MA: MIT Press, 1998), 194.

a linguistic framework which functions as external scaffolding, extended memory, and a coordination of activity via extra control loops through brain-body-world. For Clark's active externalism, a great many cognitive processes are external to the brain; 'the real physical environment of printed words and symbols allows us to search, store, sequence, and reorganise data in ways alien to the onboard repertoire of the biological brain'.[10]

In this sense, the way in which syntactical operations can be performed within formal languages is inherently machinic, since it makes immanent a set of cognitive operations that can be performed by a machine. This sense in which formal languages serve to suspend the world can be made more precise by considering that, in allowing signs to be manipulated without interpretation, we have a process through which doxastic conservatism is combatted. That is, the mechanical manipulation of syntax counterbalances 'belief bias' by suspending interference from external information such as prior doxastic and emotional states. Hence it is precisely through the blocking of our prior beliefs (i.e. the suspension of the world) that creative processes of deduction and reasoning become possible.

Consider, as an example, the development of non-Euclidean geometry. Mathematics until around the mid-nineteenth century was, for the most part, governed by intuitive or empirical considerations, for which formal language was employed in its traditional role of organisation and clarification. Euclidean geometry, until the nineteenth century, was taken to be the best description of physical space, and non-Euclidean axioms, while they were studied, were taken to be articles of fiction. What is of particular interest in their development is that the use of formal mathematical languages to investigate non-Euclidean axioms was developed in the hope of proving them wrong by proving Euclid's fifth postulate. So, for example, Beltrami's and Klein's work on models for non-Euclidean geometries are motivated in this sense, from within the intuitive space of Euclidean geometry. The failure of this project to prove the incorrectness of non-Euclidean geometry goes hand-in-hand with the increased formalization of the mathematical project in the work of Poincaré and Hilbert, whose work takes a formal language to apply over any system of objects that satisfy the specified axioms.

10. Ibid., 207.

It is precisely in so far as geometry is released from the constraints of spatial intuitions that it becomes capable of discovering non-Euclidean systems.[11]

In this way, the nonintuitive mobility of formal language can be understood to have a quasi-transcendental autonomy vis-à-vis phenomenal intuition and the structure of representation. But, given the way in which formal languages function in relation to natural language, this at the same time forecloses the suggestion that those languages in some sense have transparent access to a reality beyond thought. In other words, we have a precise means by which doxastic structures can be suspended, not in the service of metaphysical speculation that understands mathematics and logics to index a plane of immanence or Platonic realm, but in that of a ratiocination free from the constraints of human experience. Moreover, the motor of creativity here is the logic of discovery within the mechanical manipulation of syntactical and axiomatic structures, rather than metaphysical speculation drawn from intuitions regarding chaos, contingency, or absolutes—it is precisely the suspension of such intuition by mechanisms that is the wellspring of creativity.

11. For further elaboration on the historical scenario, see A. Coffa, 'From Geometry to Tolerance: Sources of Conventionalism in Nineteenth-Century Geometry', in R. Colodny (ed.), *From Quarks to Quasars: Philosophical Problems of Modern Physics* (Pittsburgh, PA: Pittsburgh University Press, 1986), 3–70.

Alex Williams

The Politics of Abstraction

What is at stake in posing the question of the aesthetic today, in light of shifts in recent philosophy towards both the speculative and the realist? Putting aside entirely legitimate concerns about the validity of such a sub-stantive object as 'speculative realism' as school of thought or movement,[1] and considering it instead as a moment or event reorienting thought within contemporary Continental philosophy in light of ideas of speculation on the one hand and realism on the other, how does this in turn recontextualise our understanding of aesthetics? If there is to be a positive upshot to such a conjuncture, it is surely to return us to the problem of representation. Into this mixture I want to throw an additional set of concerns. In essence, this is the question of a speculative aesthetics of the sociopolitical. Many of the political crises we are faced with are grounded in the problem of the abstrac-tion, complexity, and multiscalarity of the social—and in the difficulty we face in adequately representing it. One way we could think about these issues is through a development of Fredric Jameson's notion of cognitive mapping.[2] This would involve investigating the ways in which humans can marshal and master complex, abstract systems through representational interfaces, control centres, and quantitative modelling.[3]

I'm going to take a distinct but complementary approach, and try to outline the broader meaning of sociopolitical abstraction. As we will see, the term 'abstraction' in a sociopolitical context seemingly delineates at least two notions— broadly speaking, abstract phenomena emerging from material systems and processes, versus the real causal effects upon material systems and processes

1. For an appropriately unequivocal dismissal of 'speculative realism'-as-movement, see R. Brassier, 'I Am a Nihilist Because I Still Believe in Truth. (Interview with Marcin Rychter)', *Kronos*, 2011, http://www.kronos.org.pl/index.php?23151,896; and Brassier's postscript to Peter Wolfendale's *Object-Oriented Philosophy* (Falmouth: Urbanomic, 2014).

2. F. Jameson, 'Cognitive Mapping' in *Marxism and the Interpretation of Culture* (Urbana, IL: University of Illinois Press, 1988), 347–57.

3. In this regard the recent work of Nick Srnicek is exemplary.

of our abstract representations. The key questions here are: Is Capitalism the only engine of abstraction, or is it merely one driver among many? Is it enough to oppose dangerous abstractions with ideology critique, or is the plane of the abstract itself a battlefield upon which we ought to set in play new abstractions of our own? If our age is one of increasing abstraction from our lived experience, is this something to be overcome—or, alternatively, to be embraced?

Firstly I'm going to talk about the political context for this question of abstraction. Many of the most pressing political issues of today's world pose the problem of seemingly intractable alienation from our everyday, on-the-ground, lived experience—in particular, problems such as global climate change, economic crisis, and indeed the question of how to supplant capitalism more generally. Accompanying this alienation is a powerlessness, whereby politics recoils in a kind of horror at the vertigo of our abstract world. The best example of this is the rise of the idea of 'localism'. In the years following the financial crisis of 2008, a fetishization of the local has emerged as a key political tenet across the political spectrum: from far-right secessionists to the soft-right triangulating manoeuvres of Philip Blond's 'Red Toryism' and Maurice Glasman's 'Blue Labour', through to the left communism of communization theory and neoanarchism, all partake in a new credo of sustainable local communities, small-scale decision making, and localised production.[4]

The political economist Greg Sharzer has investigated some of the problems with this aesthetic of localism, in terms of the economic issues which confront a privileging of small business, ethical shopping, local currencies, and small-scale community initiatives.[5] Sharzer argues that at the core of localist economic ideas is a refusal to think systematically, to ignore structural Marxist analyses of the global economic system in favour of an ethical and aesthetic discourse, where small is beautiful, and moreover, virtuous. Such an economics is ultimately incapable of challenging the very global system responsible for generating the effects it seeks to address. Political and economic localism is certainly damaging to politics on a practical level.

4. P. Blond, *Red Tory: How Left and Right Have Broken Britain and How We Can Fix It* (London: Faber & Faber, 2010); A. Finlayson, *Making Sense of Maurice Glasman* (London: Renewal, 2011); B. Noys (ed.), *Communization and its Discontents* (New York: Autonomedia, 2011).

5. G. Sharzer, *No Local: Why Small-Scale Alternatives Won't Change The World* (Winchester: Zero, 2012).

But this still leaves open the issue of how we are to think the abstractions that it explicitly attempts to oppose or circumvent.

One of the most important attempts to think social abstraction is in the Marxist tradition, in the idea of *real abstraction*. This concept shifts the notion of abstraction from being about illusion or occupying a basically ideal register, towards the idea that abstractions can be generated by material processes. The paradigmatic thinker of real abstraction is Alfred Sohn-Rethel. For Sohn-Rethel, the commodity form and value emerge as real abstractions because of actual material spatiotemporal activities.[6] What this means, as Alberto Toscano clarifies, is that 'abstraction precedes thought'.[7] In other words, the everyday practice of commodity exchange, rendering equivalent incommensurate commodities, is an abstraction which occurs before any individual or collective thought of abstraction.

Basically, on this account, real abstraction emerges from material processes, practices, and behaviours. But there remains disagreement among Marxians as to where real abstraction began or is presently to be found. Sohn-Rethel locates exchange, i.e. the emergence of money, as being the origin of real abstraction, whereas Roberto Finelli counters that it proceeds on the basis of the reality of the labour process under capitalism, i.e. within the sphere of production.[8] But for both Finelli and Sohn-Rethel, real abstractions emerge from historically constituted practices, becoming hypostatised as abstractions, before once again taking on a new causal efficacy. Capitalistic processes of abstraction, embedded and emerging from real phenomena, become self-reinforcing and dynamic, as material feedback loops act recursively to generate entirely new domains of abstraction. The implications for action are reasonably clear: within the capitalist reality system, there exists no 'real productive' element to return to. Attempts to reform the system from within radically misread the intrinsic nature of the

6. A. Sohn-Rethel, *Intellectual and Manual Labour: A Critique of Epistemology* (Atlantic Highlands, NJ: Humanities Press, 1977), 21.

7. A. Toscano, 'The Open Secret of Real Abstraction', *Rethinking Marxism* 20:2 (2008), 280. It is interesting to note here the similarity between this account of real abstraction and Bailly and Longo's theorisation of the gestural origins of mathematics in predatory eye tracking trajectories. See F. Bailly and G. Longo, *Mathematics and the Natural Sciences: The Physical Singularity of Life* (London: Imperial College Press, 2010), 68.

8. R. Finelli, 'Abstraction Versus Contradiction: Observations on Chris Arthur's *The New Dialectic* and Marx's "Capital"', *Historical Materialism* 15:2 (2007): 61–74.

abstractions of capital. Moreover, because these abstractions are not so much in the head as in everyday life, in capitalist practices, mere ideology critique alone will never be sufficient to undo or challenge them.

But while Marxian accounts of real abstraction have much to recommend them, we ought to be wary of some of their more speculative conclusions. The temptation with many accounts of real abstraction is to shift immediately from explaining the complex dynamics of capitalism towards a rejection of abstraction in its entirety. If the essential problem of capitalism is abstraction, and abstraction is uniquely capitalistic, then this quickly leads, (perhaps detouring via the Adornian critique of instrumental reason),[9] to the fantasies of the new localist political and economic thinkers. If abstraction is intrinsically capitalistic, then emancipation can only come via a romantic politics which seeks to undo modernity itself, in order to reclaim the vanished immediacy of prelapsarian myth.[10] Real abstraction, therefore, captures some of the dynamics of sociopolitical abstraction, but fails to encapsulate others. While the spatial strategies of capitalism, towards globalization and greater integration of national markets, may partially be explained through real abstraction, this fails to grasp other globalized phenomena—for example, nonhuman ones, most seriously anthropogenic global warming. At the same time, the dynamics of real abstraction imply that sociopolitical abstraction, with its mutually reinforcing feedback loops between ideal abstraction and real/material systems, can also begin from the side of representation, as well as from practice.

What does it mean to think the causal impacts of representative abstraction from within a realist perspective? The starting point for a realist ontology ought to be minimally that the world has a reality independent of our thinking of it. In the case of social ontology then, as Manuel DeLanda has argued, social entities such as cities, nations, and communities would disappear were it not for the minds of the humans which constitute them.[11] As such, to be a realist here is simply to say that the social may in fact be other than our representations of it—that our

9. T. Adorno and M. Horkheimer, *Dialectic of Enlightenment* (London and New York: Verso, 1997).

10. N. Pepperell, 'Beyond the Exchange Abstraction', http://uncomfortablescience.org/2011/08/19/beyond-the-exchange-abstraction/.

11. M. DeLanda, *A New Philosophy of Society: Assemblage Theory and Social Complexity* (London; New York: Continuum, 2006), 1–2.

representations might be wrong. But this is not to say that such representations are incapable of having effects. The slippery reflexivity of the social means that representations, even ones that fail to grasp anything real at all about the social world, can, if properly embodied in material processes, become enormously efficacious. For example, the role played by DSGE economic theories in establishing an environment in which our present economic crisis could occur has been widely noted.[12] To admit this is not to slide into the mire of a postmodern social constructivism, which would be to erase or obviate the real in favour of an absolute determination of the social by our representations—in our current example, to claim that, because of the social dominance of DSGE theories throughout the neoliberal world, markets really did always equilibrate. The reality is more complex. The causal efficacy of DSGE economics was only made possible by its embedding within material social structures—university economics departments, thinktanks and central banks. The abstraction of DSGE theories, embedded and implemented through such institutionalisation, established a hegemonic framework in which financial actors could readily engage in the most risk-taking practices to maximise profitability.

It may be argued that such abstractions are not in themselves causally efficacious, raising the question of nominalism, i.e. the claim that abstract objects do not have ontological reality.[13] In a sense, however, the power of abstractions within the social field is distinct from the domain of the natural sciences, or mathematics. This is because, since the field is determined (at least in part) by human collective behaviour, it is amenable to influence by the kinds of representations that humans hold to be correct. Which means that, while it is true that such abstractions have no causal power on their own account, once they are coupled to human beings and the institutions they create, they are capable of contouring the manner in which human action operates. Another line of nominalist attack might be that, in this case, it matters little what the abstraction itself actually is (i.e. the structure

12. DSGE stands for Dynamic Stochastic General Equilibirum theory. For a thoroughgoing critique of this field of economics, see S. Keen, *Debunking Economics—Revised and Expanded Edition: The Naked Emperor Dethroned?* (London: Zed Books, 2011).

13. For an overview of the myriad approaches to nominalist problems, see D. M. Armstrong, *Nominalism and Realism* (Cambridge: Cambridge University Press, 1980). For an account specifically of nominalist issues associated with abstract entities see A. Hazen, 'Nominalism and Abstract Entities', *Analysis* 45:1 (1985), 65–8.

or content of the concepts), and hence that, while it is necessary that there be an abstract entity, it has no effect of its own, as its specificity is irrelevant. But this ignores the history of ideas, and the specific interactions or resonances between the conceptual and the causal which lead certain abstractions to be favoured over others.

Here, then, we find a mirror image of the Marxian real wherein representations have real effects when mediated through human behaviour, institutions, technologies, and so on. We have abstractions which arise from real material systems, as well as abstractions which have real effects on such systems. But there is also perhaps a third kind of abstraction, that which arises from the physical and cognitive limitations of the human, emerging from the play of local and global.

Why is it that locality exists at all? We begin with the physical constraints of the human body. Existing only at a determinate scale, the ability of humans, without the addition of technological prostheses, to intervene in the world around them is distinctly limited. A physical scaling structure of nested localities immediately emerges as soon as human society spreads beyond the reach of an individual's immediate senses and limbs. Such scaling also clearly relates to human cognitive capacity. A good example of this is the existence of Dunbar's number—the finding that approximately 150 people is the limit for a transparent unmediated social assemblage. Dunbar's number appears throughout social forms (from class sizes in schools to tribe numbers, and battle groups in militaries).[14] Beyond Dunbar's number, and outside the spatiotemporal locality implied by the body, abstraction necessarily begins. In this sense, then, we can conceive of certain forms of sociopolitical abstraction as being relational, the necessary effect of mediation generated by the physical and cognitive limitations of human anatomy. Our relation to an entity such as climate change, for example, is largely the result of our inability to effectively cognize it outside of technologically mediated models.[15]

14. R. I. M. Dunbar, 'Neocortex Size as a Constraint on Group Size in Primates', *Journal of Human Evolution* 22:6 (1992): 469–93.

15. For a recent take on the 'becoming topological' of human societies in the wake of abstractifying technologies such as network science and economic modelling, as well as the recent explosion in topological ideas in philosophy and social theory more generally, see C. Lury, L. Parisi and T. Terranova, 'Introduction: The Becoming Topological of Culture', *Theory, Culture & Society* 29:4–5 (2012): 3–35.

A question now arises as to the mind independence of globality and locality as such. In other words, of locality-globality in-itself, or the ground of the abstract in its maximal genericity. What is the most general relationship of the local horizon towards its global or universal container? If abstraction is, in a sense, about a transit between the local and the more generic terrains of the global, what can we learn about the manner in which such traversals may be conducted? Here the most recent work of Reza Negarestani is informative. Working from a basis informed by developments in contemporary mathematics, as well as the pragmaticism of C. S. Peirce and the geometrically inspired philosophy of science of Longo, Mazzola, and Châtelet, Negarestani's thinking on the relation between the global and the local begins with the idea of the continuum.[16] Rooted in Peirce's synthetic conception, the continuum is theorised as being an absolutely general concept, obtaining an absolute primacy over individual local instantiations. This is a concept of an absolute continuum in a sense beyond even that delineated by Georg Cantor, a 'general whole which cannot be analytically reconstructed by an internal sum of points'.[17] It is within the continuum that global and local properties are entangled. What Peirce terms 'secondness', actual existence or determination, is produced via breaks or cuts in the continuum, enabling the marking of differences to become possible.

Negarestani follows Peirce in considering the relationship between regional, localised horizons of the universal of the continuum in terms of 'cut-outs'. Because all localities are cut from the cloth of the continuum, regional interiors need to be considered as indefinite in nature, blurry and fundamentally existing in a state of fusion, open both to other localities, and remaining in relation to the global of the continuum.[18] Exteriority, therefore, always maintains multiple pathways by which it might enter an interiorized horizon. These potential pathways by which the exterior and more global can erupt into the local are considered to be vectors of trauma—as Negarestani puts it, a piercing 'from multiple points of view, and nesting; it does not amputate, but transplants'.[19]

16. R. Negarestani, 'Globe of Revolution', *Identities* 17 (2011), 25–54.

17. F. Zalamea, 'Peirce's Continuum: A Methodological and Mathematical Approach' (2001), http://acervopeirceano.org/wp-content/uploads/2011/09/Zalamea-Peirces-Continuum.pdf, 7–8.

18. Negarestani, 'Globe of Revolution', 25–7.

19. Ibid., 30.

Hence the Negarestanian injunction, or 'eleventh commandment', to ramify every pathway, to explore the interconnections or addresses existing between localities and more global topological structures.[20] What this kind of navigational rationalist account of the global and the local points out is that neither the local or the global is primary over the other; rather they are mutually bound up with one another, and there is always potential for perforation, and possibilities for transplantation or transition.

By way of concluding remarks, it is clear that abstraction is a necessary consequence of complexity (on a formal or social level). The nested structure of multiply-embedded localities, as well as mediational political or economic structures, are the price that human social systems pay for the benefits accrued through increasingly complex societal structures. As such, attempts to evade or otherwise obviate abstraction appear fated to failure. Deleterious social abstractions, such as those trafficked by neoliberal capitalism, cannot be destroyed through ideology critique alone, given their grounding in everyday practice. If abstraction is more than simply an effect of capitalistic systems, structures, and processes, being instead the very substance of modernity, we ought to disabuse ourselves of all notions of prelapsarian return to an intrinsically tractable world of organic wholeness. In its place, we must arrive at a coming to terms with abstraction itself. This is to say that a new politics, and indeed a new aesthetics, must aim towards an overcoming of the negative relationship to processes of alienation which are simply the indicative hallmark of our increasing ability to transcend the limits imposed on us by our evolutionary heritage.

20. R. Negarestani, 'Abducting the Outside' (Public lecture, Miguel Abreu Gallery, New York, 2012).

Ray Brassier

Prometheanism and Real Abstraction

There are lot of materials here to try and synthesize; I'll just try to talk about a couple of things, and to pick out what I take to be the decisive factors in Nick's, James's and Alex's presentations.

First of all, Nick's distinction between epistemic and political accelerationism is absolutely crucial. Making this distinction allows us to understand the core issue of acceleration and to frame the problems of accelerationism correctly. The problem of acceleration has both an epistemic and a political aspect, and it's tied to this issue of abstraction: to the epistemic status of abstraction on the one hand, and to the political valences of abstraction on the other. So, I agree that the question is how these two can be articulated.

Now this is also tied, I think, to the emphasis on navigation that Nick indicated. That is, to understand the coordination of epistemic and political abstraction is to understand how representation functions; and this is to see representation from a naturalistic perspective as well as in terms of what humans have in common with other animals—in other words, we have a whole set of cognitive capacities that are basically a navigational system. That the problem of thinking is tied to the problem of movement is a very interesting hypothesis: you need to have a brain because you need to be able to move.

Here it's important to distinguish conceptual function from representational function. Now, conceptual function is inferentially articulated, whereas representational function is basically a mapping function. And mapping is about navigation. The prospect of achieving a stereoscopic synthesis of the so-called manifest and scientific images is really about integrating conceptual function with representational mapping. Now, both of these are practices—they are both forms of knowhow. Knowing how to connect, combine, and dissociate concepts is a kind of knowhow, it's a cognitive skill that human beings acquire by being inducted into the cultural dimension.

By way of contrast, representational function is straightforwardly biologically determined on some level. So achieving an integrated understanding of these two aspects would require explaining how conceptual function can augment or amplify navigational capacity.

In other words, the suggestion is that concepts can facilitate the production of fine-grained mappings of reality. This is what I think Wilfrid Sellars means when he talks about the stereoscopic synthesis or fusion of images: the ideal end of cognitive inquiry consists in a fusion of theoretical and practical knowledge in which our theoretical understanding allows us to realise all our practical goals and purposes. This would be the point at which the distinction between theory and practice is dissolved.

Now, the key thing, I think, is the question of social construction, because both conceptual function and representational function are embedded in a sociocultural context. So in order for this stereoscopic integration of the manifest and the scientific, the theoretical and the practical, to be achieved, we must understand how each can be virtuously injected into the other.

This is a speculative proposal, but I think there is a clear tie here to the legacy of the Enlightenment, in so far as enlightenment is understood as the achievement of autonomy, which is to say, self-determination through rational self-governance. So, in other words, the stereoscopic integration of theory and practice, or of truth and goodness, can only be achieved through a project of collective self-mastery. When human beings have understood themselves— including their biological inheritance and their physical constraints—sufficiently well to be able to refashion themselves, they can refashion the world to make it amenable to rational ends.

This, I think, is the most philosophically significant component of the Marxian legacy: its insistence on the need for the material realization of the Promethean prospects opened up by the Enlightenment. I take it that this also underlies Marx's claim about what is distinctive in human species-being: human beings have this unique capacity to transform themselves and their world because of the fundamentally social nature of human existence.

Now, any attempt to expand both the cognitive and the political ramifications of the mapping function will require a fuller understanding of the political debilities that afflict much contemporary left theorizing. For instance, Jameson's emphasis

on cognitive mapping seems to be dissociated from any kind of practical political consequence beyond that of critique. The critical task is to produce cognitive maps of capitalist reality which will provide traction on the real abstractions dominating every aspect of contemporary existence. This is certainly valuable, but it does not seem to be tied to any kind of political practice. Mapping for the purposes of critique alone is not going to help you overcome capitalism.

This disjunction between critical theory and political practice is paralysing. I think there is a long story to tell about how it has come about, and I think that Jameson here is the inheritor of something that arguably originates with Lukács. My suggestion is that, given that Marxism is about achieving the integrated fusion of theory and practice, of understanding and transformation, it is imperative that we reengage with a hundred and fifty years' worth of cognitive development in physics, biology, cognitive science, etc. And here I think James's account of doxastic conservatism is related to the way in which conceptual functions take conceivability as constraint, and are limited by some combination of bio-socio-cultural functioning. So I take James to be pushing forward with the project of epistemic acceleration. Philosophical blindspots constrain conceptual possibility, and this constraint on conceptual possibility has political consequences.

Now interestingly, what is controversial about this is finding a way of rooting conceptual practice in social practice without simply identifying the former with the latter. A straightforward criticism of this move is the claim that conceptual norms are overdetermined or constrained by sociocultural norms. I think there is a way to overcome this kind of objection, but doing so requires a theory of function that dissociates conceptual function from representational function: conceptual function involves a certain plasticity because it is equipped with a kind of inbuilt machinery for self-revision.

This kind of conceptual revision becomes the condition for practical revision, for the coordination of means and ends. Because if one refashions one's understanding of the space of conceivability, this has obvious ramifications for how one understands what is possible, and for what one can actually achieve in a given practical situation.

A few concluding remarks about abstraction: The key thing is to understand the distinction between the abstract and concrete methodologically rather than metaphysically, and I think this is precisely what will prevent, for instance, the

Marxist theorization of social abstraction from lapsing into a kind of nostalgia for a prelapsarian unity before social relations became mediated by abstract forms. The notion that human means and ends will only be harmoniously coordinated once reembedded in an organic community uncontaminated by abstraction is a neo-Aristotelian fantasy that afflicts too many Marxists. By the way, I think Alberto Toscano's recent work on real abstraction is really very important here.[1] It's an attempt to understand how epistemic and political abstraction might be articulated from a Marxist perspective.

It's also important to avoid giving a circular definition of real abstraction by explaining the reality of abstraction in terms of its causal efficacy, while defining causal efficacy as whatever makes a difference in reality. This is not a very helpful explanation of what constitutes the reality of abstraction. Once this is understood, one realizes that there is nothing one can invoke as any kind of infallible index of the difference between the concrete and the abstract. This is the whole point of Sellars's critique of the given. Once you have dispensed with the idea of the given, you realise that nothing is either abstract or concrete in itself: there is no metaphysical fulcrum for this distinction. Even at the level of perception, no immediate experience would provide you with a litmus test for distinguishing the two. Concrete immediacy is constituted through abstract form. In this regard, alienation can be understood as the constitutive fissure of self-estrangement through which sensation is conditioned by conception. Understood in this way, alienation is constitutive of rational agency and hence the condition of freedom. So there's a sense in which alienation can be understood as an enabling condition for the achievement of collective self-mastery and refashioning which I take to be constitutive of Prometheanism. There is no going back to some allegedly originary state of organic immediacy. To be rational is to have always already been expelled from the state of nature. This is basically to ratify the realization of abstraction as a kind of research programme.

Unless Marxism reasserts its commitment to Prometheanism, and to the transformative power of conceptual rationality, the result will be a politics of fear masquerading as a politics of emancipation. It is quite striking

1. See e.g. A. Toscano, 'The Culture of Abstraction', *Theory, Culture and Society* 25:4 (2008), 57–75; 'The Open Secret of Real Abstraction', *Rethinking Marxism* 20:2 (2008), 273–87.

to observe the extent to which the contemporary Left is paralysed by fear of the future. A hundred years ago, it was the Left that laid claim to the future, whereas the Right wanted to return to or reestablish the past. Now the situation seems to have been reversed, and what's striking about the kind of abject terror sparked by evocations of ecological catastrophe is that it is politically paralysing. But you cannot have an emancipatory politics rooted in fear, because freedom from fear is the precondition of emancipation. The politics of fear is ultimately the politics of reaction, of self-preservation at all costs. But a species whose only concern is its own perpetuation does not deserve to exist. If the best we can hope for is just our own perpetuation then there is no reason to perpetuate ourselves.

What are the implications of all this for aesthetics? Well, perhaps it's not so much a question of pitting the conceptual against the aesthetic, or concepts against affects, but of developing a conception of aesthetics which is not exclusively governed by either: one dedicated to reconstructing sensation on the basis of new modes of conceptualization. A Promethean constructivism will engineer new domains of experience, and it is these new domains that will need to be mapped by a reconfigured aesthetics.

Discussion

ALEX WILLIAMS: I find this very interesting, the idea James puts forward of formal languages being a kind of technology, a technology which isn't just a way of organising intuitions about the world, but instead has the potential to surprise us. Things could come out of them which are not simply reducible to the input, in the sense that you can learn from them, and that's really intriguing. My question, given that abstraction of some kind seems to be at the core of this (in that it's not just expressive of common sense) is how are we able to form these languages in the first place—formal languages that are not just an abstract system, are not disconnected from the world entirely to the point of just being a game. They have some degree of traction within the real and yet they still have abstraction. I wondered if you could expand on this, especially given the current currency of the ideas of philosophers such as Giuseppe Longo, who present a story about how abstractions, mathematics for example, get 'into' us from the outside.

JAMES TRAFFORD: Yes, it's a good question; I think it's tricky, partly because there is no clear methodology for approaching it. I think the short way of thinking about this would be to suggest that you take the 'good' bit of grounded cognition, where you can understand conceptual activity as essentially grounded in some sense. We can think of this as an essentially associative structure where there is a relationship between this and the way in which a cognitive system is in bodily interaction with the environment through various things like gestures, etc. But this isn't all that there is to cognition, reasoning, and so on. Even six-month-old children, and even rats, seem to have some sort of generalized association relating to negation—there are a bunch of experiments suggesting that even very young children have some sort of abstract concept of number, for example. These processes of cognition are all going to be pretty mundane, and, of course, we use things like elementary language to begin to structure these associations and to modify them in different ways—systematizing social interactions and that kind of thing. But that's not the whole story—this is the point of the account of doxastic conservatism—because we can use the technologies of

formalization to combat this, and think of it in terms of a generative process which expands the resources of our language, differentiates our abilities to reason, and so on. In other words, we can develop new abilities that far surpass our initial biosocial conditioning. For example, I think that the traditional idea that we can tether logic to some sort of independent logical structure really holds this back by presuming we have some kind of transparent access to semantics. Instead, we need to think of logic in terms of rational constraints, which are open to processes of revision and navigation, and then whatever we understand by logical consequence and semantics is going to need to be far more flexible.

AW: I'm also interested from the point of view of the geometric aspect of Longo's work: How is it that you go from some kind of bodily movement through space, or eye-tracking, the ability of predatory animals to track the motions of their prey, to this kind of conceptual structure? The question is, in a crude sense, how do you transpose from these physical gestures towards some kind of cognitive or rational process—i.e. make the ur-abstraction or original abstraction? And having begun such processes, how is it that the ur-abstraction is preserved, maintained throughout (with mathematics, for example) thousand of years of transformations and elaborations? How do you preserve the originary abstraction?

JT: Basically, the initial processes of cognition of these things are going to be grounded in the world in some sense. For example, something approximating negation is going to be learnt by children, possibly as a very basic incompatibility relationship: something can't be both red and green at the same time. And what happens is that you're going to get this introduction into representational structures or semantic structures that are associatively conditioned by input, by the habit of these things being triggered. But then we're using language to systematize those structures, to revise them, and using something like logic to construct community-level norms.

TOM TREVATT: I was thinking of ways of drawing this whole conversation into the more mundane sense of the aesthetic, of art. Ray spoke a bit about this notion of Prometheanism. There are ways of connecting that to things Benedict

was saying earlier, about the role of design; and there's a way in which you can think of design as being precisely, in its original function, to do with changing the world. This is a very important aspect of design, but also, as Benedict pointed out, within this is a disavowed sense of design as, increasingly, designing people's behaviour; and even reshaping their subjectivities—are they comfortable with this?

To bring in art, now, what's the relation of art to a promethean Marxism? Can it be a tool within this sort of project of remaking ourselves, remaking the world? Or is it something to do with the structure of art—is its resistance to a purposiveness, to instrumentality, going to be a block to that, limiting art to being a supplement to something supposedly more instrumental? So basically, how do we situate art in relation to that wider project?

RAY BRASSIER: This is where the relationship of the aesthetic to the conceptual becomes relevant, though also problematic. Art, whatever physical medium it's operating in, ultimately must have some conceptual content. It must operate conceptually on some level. Now, you can have a sophisticated understanding of conceptualization that does not identify conceptual content with propositional content, so this doesn't have to be a banal claim. For instance, if you ask: How does a piece of music embody thinking? Obviously it can do so in an incredibly complicated way. The fact that its conceptual content cannot be linguistically recoded in any kind of digestible propositional form doesn't mean that it doesn't have conceptual meaning. The argument to the contrary seems to run: Here's a piece of music which is obviously cognitively sophisticated in terms of everything that is actually going on in it—but how could this possibly be conceptual if by 'conceptual' you mean something that can be encapsulated in propositional form? I think this is an unnecessary simplification. Although everyday conceptualization—whose primary function is practical or communicative—uses linguistic resources, this doesn't mean that every thought can be straightforwardly individuated in terms of a set of propositions. And this is as true for literary art as for music or the plastic and performing arts. If concepts are understood in terms of their functional role, then perhaps what distinguishes the thinking peculiar to art consists in constructing nonpropositional functions by making materials—linguistic, sonic, plastic, etc.—do things we don't expect

in ways we couldn't have anticipated. Art is the construction of function, as opposed to the relaying of preestablished function.

By obliging you to conceptualize its nonpropositional content, art may make you think about the status of sensation, about what hearing is or what seeing is, and ultimately, what feeling is. So art can perform a subversive epistemic function which feeds into Prometheanism's broader emancipatory agenda. It seems to me that modernism in art is the idea that by challenging clichéd ways of perceiving, you can encourage people to think about the way they see things, rather than continue to see the world as it is generally accepted to be. This is to begin to understand things differently, but also to expose the various invisible mechanisms that condition habitual perception. This link between cognitive subversion and emancipation is what I would like to retain from the modernist ethos.

So I would say that art can play an emancipatory role consonant with the Promethean imperative, but not by proclaiming this ideal in some platitudinous sense. Promethean art need not be about 'Prometheanism': it can challenge our beliefs about ourselves and our world in a way that invites us to remake both without having to enunciate this as a propositional injunction. Art can further the Promethean project without subordinating itself to it as an extrinsic goal. In other words, it can be useful, but precisely by preserving its uselessness. It is the subversion of designated function that functions revolutionarily, not the assertion of the need for a revolutionary function. Perhaps this is a cliché but I still believe that genuinely revolutionary art has to be abstract in the sense of uprooting default modes of thinking and feeling. It should challenge bourgeois epistemic norms, by which I mean cultural conventions stipulating what we ought to think or ought to feel. This is not a new idea, but I want to defend it, and insist that art uses the sensible to teach you to distrust your sensations—don't trust what you feel!

PETER WOLFENDALE: There's a Deleuzian distinction between art as communication and art as composition which is really useful here. I think Deleuze's critique of the communicative use of art, where the art is giving a message to the viewer, as fundamentally reducing art to this sort of discursive register, is valid. But you can easily go too far in that direction and say that therefore art cannot have any sort of conceptual element to it. I think the important point is that, even

if you view art in terms of composition of affects and percepts, concepts are materials of composition. You can compose with concepts.

In relation to James's presentation, I wanted to return to the whole logic question, and why I think Brandom can answer the kind of things you are talking about. In *Between Saying and Doing* Brandom gives a really complicated story about what logic is and how we can have logical abilities.[1] His basic idea is called logical expressivism, and it's the idea that what logic does is enable us to *make explicit*—it's a tool for making explicit what's already implicit in what we say. This doesn't mean there has to be a single logic—there can be different logical vocabularies. I think this is interesting in relation to your idea of doxastic conservatism. What I would add is that, if you take a sort of Sellarsian approach to semantic content—if you see the semantic content of a nonmathematical expression as constituted by its being involved in material inferences, then you see these material inferences as being fundamentally, principally, non-monotonic. You can tell quite an interesting story about what it is to be caught up in a given horizon of possibility, because basically what you get with non-monotonic inference is that the inference is only good as long as you accept a whole bunch of assumptions. Another way of explaining that would be in terms of the shift from non-monotonic frames of inference to purely monotonic frames of inference, which is what you get in mathematics. So that is the way I saw your talk about semantic activation and desemantification, and how this relates to logic. What I want to say to you is, do you really resist this sort of semantic picture? Or do you think that there's an alternative semantic picture?

JT: To an extent I might disagree with some of this picture, though it's going to depend upon how it's cashed out. One thing that's really important is that I don't think that you can define the meaning of logical terms using inferential rules if they are supposed only to explicate underlying implicit linguistic moves. There's a whole set of issues that are raised within this understanding of inferentialism. These concern, for example, the ways in which the sort of proof-theoretic characterization of logic in Dummett is connected with anti-realism and its emphasis on provability. Then, of course, there are issues

1. R. Brandom, *Between Saying and Doing: Towards an Analytic Pragmatism* (Oxford: Oxford University Press, 2010).

relating to what we say about bad inferential patterns such as the famous example of 'tonk'. This relates to how we understand meaning to be defined by certain inferential roles; which roles get to count as defining meaning, and that kind of thing. We need, for example, some way of 'weeding out' the inferential rules that seem like they should be kosher, but clearly aren't. In this sense, I think we require a very flexible understanding of the way in which the semantics of expressions is determined by inferential rules. I do think that this is entirely possible though, when we move to an understanding of rules in terms of rational constraints. Also, if we start with Gentzen's symmetric sequents, then there's a clear sense in which the syntax can be seen as generative of semantics (using a generalized form of Lindenbaum-Asser constructions), and so, semantics is, in a sense, internal to the way in which we construe syntactical rules, i.e. without reference to an external reference or independent reality.

PW: It feeds into what was said about functional classification: there are levels of functional classification of logical operators that are not so fine-grained as to pick out an operator within a particular domain—they don't distinguish between classical negation and intuitionist negation.

ROBIN MACKAY: James talked about the operations of desemantified formal languages; then Alex talked about the fact that we can't evade the task of finding some new ways to grapple with the abstractions that surround us. The question of how desemantification, abstraction from, let's say, the manifest image, works has emerged as a key question.

Now, if aesthetic experience is never preconceptual, if there's no ultimate guarantor of the distinction between abstract and concrete, then surely all we are dealing with is abstractions (plural) from X to Y. Certainly as far as animal perceptual behaviour is concerned, we can say that it already operates through abstractions (Longo; but also, already, Bergson's point about perception always being a *subtraction* from what is given).

New abstractions can come to command and direct the substrate from which they emerged, and even potentially modify it in an enduring way. It would be foolish to think that any abstract model can ever perfectly fit the

reality it's trying to grasp, and therefore there is always a gap where novelty can slip in, there's always a kind of grinding of the gears in which new problems are produced, no matter how powerful the purchase of a given abstraction may be. Surely that production of new problems simply is the story of collective cognition.

Because whatever may take place on an individual level in terms of the loosening and shifting of these given abstractions only becomes truly significant when it takes place within a collective cultural context. And it seems to me that art (institutionally understood) simply doesn't do this: as an experience or set of experiences, it doesn't have a long-term relation to behavioural feedback loops or to collectivity which would enable it to make its abstractions real. Art doesn't do that whereas, for example, computer games, music, popular use of technology, and so on, certainly do—they manifestly change behaviours and modes of thought and gesture, action. Look at smartphones, Facebook, Twitter: the way that people interact with the world psychologically, physiologically, is genuinely being changed. It's not philosophers who are doing that, and it's not artists, it's corporate design and strategy, and technology. It produces real change and real, novel problems, pathologies even. Understanding the concretizing processes of abstraction, the way in which they make themselves real, is the only way one can hope to direct them in the Promethean sense that Ray suggested. And it's not clear how art might contribute toward that task given its obsession with providing indeterminate 'spaces of reflection'.

BENEDICT SINGLETON: My question is actually related, and is about Prometheanism. That idea seems very important to all of you. What I wonder is how that relates to whether there's a sort of contradiction between certain embodiments, cognition or whatever, versus the myth of the given. I think it was suggested that there was some sort of tension between the two.

RB: I don't think there's necessarily a tension between acknowledging the embodied aspect of cognition and rejecting the myth of the given. The tension can be dissolved by distinguishing between conceptualization and representation, or thinking and mapping. The hypothesis that brains originally developed as navigational mechanisms suggests that the most elementary function of cognition consists in representing the environment well enough to escape predators

and seize prey. So from a biological point of view, representation's primary task is to map the organism's environment. To the extent that all thinking developed as a function of biological locomotion, then it's correct to say that mapping is thought's originary function.

But even if thinking originates in movement, it would be a genetic fallacy to insist that all thinking is necessarily subordinated to navigation and the plotting of trajectories in space-time. This may well be representation's most elemental function, but concepts are not representations, and the concept's role is not representational. It's crucial to distinguish these two aspects of cognition: the conceptual and the representational. Concepts are individuated in terms of their inferential role, whereas the role of representations is mapping. In one sense, the myth of the given consists in conflating concepts with representations, or inferential function with mapping function.

Of course, this is not to say the two modes of functioning are wholly disconnected. We need to study the neurobiological mechanisms that underlie our conceptual capacities using the resources of empirical science. But the contemporary discourse of 'embodiment' is not motivated by any regard for naturalism. It's not concerned with understanding the neurobiological basis of cognition. Embodiment is understood in a phenomenological register as 'lived experience' and inflated into an irreducible datum, an unexplained explainer. This is precisely what a neurobiological understanding of embodied cognition ought to displace. There is a way of understanding the constraining role that our biological legacy exerts upon our conceptual capacity, but it does not consist in reducing conceptualization to representation. To do so is to fall back into the empiricist variant of the myth of the given by treating concepts as representations. This is also to confuse reasons with causes. The world causes representations and representations may cause occurrences in the world, but even if concepts supervene on representations, they are neither caused by things nor can they be the causes of things. We have to use concepts to understand the neurobiological processes that underlie conceptualization. But to identify those concepts with the processes they are being used to investigate is to engender paradoxes which threaten science's epistemic integrity.

BS: I think that perhaps in the account of Prometheanism there may be a contradiction between the articulation of conceptual structures and lived experience, which may be related to how we can understand abductive thinking as being a kind of going back before going forward.

RB: Yes, perhaps there is. Abduction can be understood in terms of cognitive neurobiology because it is rooted in association. Associative synthesis is at the heart of connectionism. There's good reason to believe animal representational systems are basically connectionist. I think James mentioned the kinds of associative networks that develop these preestablished pattern configurations to synthesize information. Churchland says something similar in *A Neurocomputational Perspective*: a prototype vector is activated as the best explanation for a heterogeneous perceptual input.[2] He proposes a neurocomputational account of abductive inference. Such inferences facilitate the sorts of recognitional prowesses exhibited by higher organisms. But I would insist that there is a difference in kind between the connectionist machinery at the heart of animal representational systems, whose operations are associative and Humean, and conceptual explanation in the strict sense, whose functioning is inferential and Kantian. In other words, we can explain how animals are engaged in predicting their environment, and we know that we rely on some of these same neurobiological resources in predicting our own environment, but we are also able to conceptualize these resources such that they become reflexively articulated. We are self-conscious about the ways in which we are engaged in predicting the world, in a way in which animals arguably are not (I don't mean 'self-conscious' in a phenomenological sense here; I just mean reflexive). So although there is a definite continuity from sentience to sapience, there's also a discontinuity or phase transition: something important happens in between sea slugs and humans—there's a difference in the kind of cognition at issue, rather than a mere difference in the degree of cognition, although I realize some naturalists would want to deny this.

2. P. M. Churchland, *A Neurocomputational Perspective: The Nature of Mind and the Structure of Science* (Cambridge, MA: MIT Press, 1989).

NICK SRNICEK: Building on Ben's comment regarding the origins of rational thought, I want to think about how we understand the ends of rational thought. I think there's a huge open question here. For instance in Reza's work I think there's this idea of ramifying the pathways of conceptual consequences, and tangentially approaching a complete picture. Sellars is right I think to highlight this normative aim of a complete and true picture of reality, and I think that answers to the regulative ideal of rationality. But is this aim of scientific knowledge sufficient to underwrite political projects? I'm not sure it is. And so I think there's this big question about what the normative end of this stuff might be: What is accelerationism *for*?

RB: But isn't it part of the definition of acceleration that we don't know where it might lead? How could we anticipate its end on the basis of our current cognitive resources? Still, I agree we must be able to rationally conjecture certain necessary characteristics of this end, otherwise it collapses into an ineffable alterity, which we have no good reason to pursue. But this is not to say we can predict it.

AW: There is certainly an element of that in Negarestani's idea of navigation—the notion that there isn't a predetermined end point or teleological objective, but there is a certain teleodynamic directionality. I think this is part of what Nick Srnicek and I want to extract from Reza's work, to help develop a kind of leftism which is distinct from traditional Marxism—the idea that we don't know what the ultimate end will be, and that processes of navigation, in thought and action, inevitably open up new horizons, horizons which may be well beyond our present imaginings.

RM: Isn't acceleration to do with hooking the project of human emancipation to the essentially psychotic project of scientific rationality which demands that, if any path can be explored, then it *must* be...? Which is not an end as such, it's just a protocol for escape.

BS: I think this relates to something which is a nice bit of a corporate cosmology around platforms, and how companies like Facebook and Google actually work,

which completely wrongfoots traditional business theories, because they are not products or services.

This relates to how we understand platforms, and how the design aspects regarding platforms relate to *plot form*. One of the interesting things about platform logic is the following: take Facebook moving into Africa—'the next billion Facebook users', as they are quite explicitly calling it. Is there a rationale for it? They just know if they do that then there will be more stuff to do. I mean, it opens up massive space of possibility. Because they are particularly in a capitalist position they are able to persuade other people to give them money to do it. Effectively, that kind of platform logic seems to be something which is in line with certain of these ideas about acceleration and so on: you build it because then you open up further possibilities....

AW: That's why epistemic accelerationism is still accelerationism: there is this psychotic element to it. It does not become reasonable. It is rational but it does not necessarily become reasonable.

Mark Fisher

Practical Eliminativism: Getting Out of the Face, Again

I want to talk about the problems around the concept of experience. But I'll start with an accelerationist genealogy, starting off with the position that many of us were oriented around in the 90s, which was Nick Land, Landianism. This was a kind of hyper-Deleuzianism, a dark Deleuzianism, but one which was still organised around the problem of experience, I think, in Nick's theory. You can trace that back to Bataille, the kind of impossible quest to experience not only the maximally intense, but beyond that, the quest to experience from a position where experience itself is not possible; i.e. death, death itself as the limit.

I think one of the crucial moves of the last few years was to move *against* experience, actually. Rather than pursue this kind of quest for an impossible experience, instead to point out the contrast between the cognitive and what can be experienced. So, as it were, death—not just individual death, but hyper-death, and not just the unexperienceable, but the evaporation of the very possibility of experience, via extinction or whatever—becomes contrasted to experience as such. You can't experience extinction, and so we no longer worry about that.... Instead, extinction becomes a speculative and cognitive challenge.

I think this was a crucial move, but it has serious consequences for this question of the aesthetic. Put simply, how can one have the aesthetic without experience, at all? If the aesthetic must involve some kind of experience, how can we think about what experience is without relapsing into familiar theories? On the face of it, the 'speculative turn' has little to offer aesthetics. In some ways, the emphasis on mind-independent reality, whether in its OOO-phenomenological mode or in Ray [Brassier]'s anti-phenomenological form, can be construed as an anti-aestheticist move, in the sense that it is a decisive rejection of deconstruction's literary poetics of indeterminacy *as well as* the Deleuzian ontology of affects and intensities.

One decisive move it makes—which separates it from the accelerationist antihumanism of Nick Land—is the rejection of what Ray, in 'Genre is Obsolete', calls the 'myth of experience'.[1] We can understand this in terms of the impasses of affect theory, actually. Affect theory was quickly taken up in various discourses around the art world. And part of the reason why Ray's work was important is that it really called out the way in which affect theory is used as an alibi for all kinds of anti-propositional, anti-argumentative, anti-rational, anti-lucid kinds of discourses. It became a kind of theoretical aestheticism, which became really boring. The hymning of sensation, affect, etc., became really tedious. So for me it's an issue: if we want the aesthetic, we must have experience in some sense; but what do we mean by experience, now?

I think in some ways this rehearses the old dispute between Hume and Kant, with Deleuzian affect theory as a form of return to Hume, and the idea that you can have sensations that do not require a subject as their guarantor. But what I want to suggest is some sort of return to a Kantianism. Not to Kantian aesthetics, nor to his metaphysics and epistemology actually, but to the crucial difference between experience and conditions of experience.

As Ray was asking earlier, what is the value of the alienating power of the arts in modernism? It's an experience that makes one question one's own experience. And one way of putting that would be, then, that it is an experience which confronts one with the conditions of experience. And beyond Kant is the move from Transcendental Idealism into Transcendental Materialism, where plasticity goes all the way down, where the conditions of experience themselves become subject to transformation, etc.....

The constitution of our subjectivity in everyday life is the product of various forms of engineering and manipulation; the reality in which we are invited to live is constructed by PR and corporations, is a form of libidinal informational engineering. So I think this mandates a kind of counter-engineering practice that must be undertaken. To follow on from Robin's point at the end of the previous discussion, we've seen massive behavioural mutations of the human population in the last decade. But they're turning towards banal ends, such as Facebook, smartphones, etc. What you're seeing are behavioural tics that have passed through a population, i.e. looking at a screen, digital twitch, etc.

1. R. Brassier, 'Genre is Obsolete', in *Multitudes* 28 (Spring 2007).

These behaviours were not in place ten to fifteen years ago; it was impossible for them to be in place. Now they are ubiquitous.

The practical question, and it's a schizoanalytic one, is whether that is only possible on the basis of faciality. You've got a kind of deterritorializing mutation here where, although the behaviours are quite banal, they are nevertheless radical in terms of the addictions and compulsions that are involved. Obviously people don't undertake them on the grounds that they are participating in this kind of mutational vector. They undertake them on the grounds of folk psychology. The brain and fingers can become this kind of libidinal assemblage only because the mind is distracted by this pull of folk psychology. Folk psychology is a practical kind of cultural proposition in which we live, and I think one of the deep sadnesses, one of the miseries of the twenty-first century, is the return of folk psychology and the depletion of the resources of the depersonalization that culture once offered.

Much contemporary art has reached an extraordinarily decadent pass, where a typical work is radically denuded of aesthetic texture. A fear of content seems to have a tyrannical hold, motivating 'works' which consist of banal discursive pre- (and post-) texts attached to super-banal objects which, at worst, trigger neither thought nor sensation (to expect either is, apparently, to be a vulgarian) and, at best, indirectly invoke some mildly diverting process which led to their construction. The justification for this kind of production seems to be a worst-of-all-worlds mixture of post-conceptual cognitivism without concepts (which makes aesthetic texture passé) and the post-Deleuzian celebration of infinite creativity (which outlaws any negativity by imposing a mandatory affirmatory imperative—don't complain!).

Yet, while contemporary art seems especially played out, it is not as if the other cultural zones which had in recent years superseded visual art as the leading edge of cultural experimentalism are immune from the processes of inertia which have reduced contemporary art to an anxious vacuum. There have been no significant transformations in electronic music for about a decade, and the best we have come to expect is minor incremental shifts and sophisticated pastiche rather than any new sounds and/or sensations.

Meanwhile, mainstream culture has become increasingly reduced to folk psychological interiority. Whether it's reality TV or social networks, people have

been captured/captivated by their own reflections. It's all done with mirrors. The various attacks on the subject in theory have done nothing to resist the super-personalization of contemporary culture. Identitarianism rules. Queer theory might reign in the academy, but it has done nothing to halt the depressing return of gender normativity in popular culture and everyday life. Elements of 'leftist' politics not only collude in, but actively organise this rampant identitarianism, corralling groups into 'communities' defined according to the categories of power: a Foucauldian dystopia.

So instead of this thing about dancing and games, that Robin talked about, instead of that, increasingly cultural time is taken up with forms which, at the psychological level, mirror people back to themselves in the most banal possible kind of manifest image. The question now is whether a certain kind of defacialization can be recovered—whether a practical, not merely theoretical, eliminativist project can be resumed, and whether we can start getting out of our faces again.

Robin Mackay

Neo-Thalassa:
A Fantasia on a Fantasia

Sándor Ferenczi's *Thalassa*, written in 1924 but based on ideas dating from 1915–1920,[1] is really a very peculiar book, described by the author himself as the result of a strictly inadmissible synthesis of 'natural science and mental science'.[2] Its subtitle positions it as 'A Theory of Genitality'—that is, it presents an alternative account to Freud's own of how polymorphic, disorganised libidinal drives become invested in the genital organs and thus aligned with the exigencies of organic reproduction. How do unformed blind inorganic forces disposed to perversity become integrated into and harnessed for the interests of the organism? What kind of libidinal investments and psychic processes correspond to this process of maturation? Freud's 1905 *Three Essays* gave an account of this process, whose ineluctable completion will ultimately ensure the dominance of the 'end-pleasure' act of coitus—the 'definite normal form' of sexuality, the 'new order of things' in which '[t]he sexual impulse now enters into the service of the function of propagation'. This is both the end of the path of sexual development and the successful delivery of the adult from diverse and perverse 'forepleasures' to the reflex act of coitus. In short it is a question of how psychic life adapts itself to organic life, rebinding contingent pleasures to healthy organic function (a process interruptions of which psychoanalysis aims to correct).

Ferenczi's primary innovation in *Thalassa* is to extend this analysis to the peculiar character of the act of copulation. This is an entertainingly bizarre project in itself, but has a bearing on speculative aesthetics through the theory of symbolism that emerges along the way.

In its first stage Ferenczi's analysis supplements Freud's account of sexual development with the observation that the sexual act itself seems to comprise a

1. S. Ferenczi, *Thalassa: A Theory of Genitality*, trans. H. A. Bunker (Albany, NY: Psychoanalytic Quarterly, 1938).

2. Ferenczi, *Thalassa*, 2.

combination of the 'evacuatory and inhibitory' ('urethral' and 'anal'): the act itself expresses an indecision between these two basic tendencies, and, as Ferenczi hears from his patients, failure to successfully resolve their duality results in 'a kind of genital stuttering' (*ejaculation praecox* or *ejaculation retardata*). This *amphimixis* of erotisms, existing already in pregenital organization as the mutual adaptation of hedonism and renunciation, furnishes the clue for understanding the process of the 'establishing of genital primacy'. With the latter, warring instinct-components are amphimictically subsumed under an 'executive manager' responsible for periodically discharging tension 'on behalf of the whole organism'; meaning that the phallus, also, becomes a representative of the ego.[3]

Guided by dream symbolism, Ferenczi reads sexual development in terms of the postulation of a 'continuous regressive trend toward the reestablishment of the intrauterine situation'—the famous 'back to the womb' theory.[4] Whereas the reality principle, of course, is only attained in renouncing such desires, Ferenczi insists on an 'erotic reality sense' that consists in its hallucinatory fulfilment. There is a threefold identification and gratification at stake in this fulfilment which involves a kind of *relay* between levels: as the sexual secretion closes the *biological* circle of reproduction, *actually* 'returning' to the womb, the genital organ—invested as a synecdoche for the organism as a whole—*physically* discharges the tension of the body; and the whole psyche, with the organism having appointed the genital as the executive agent to drain off its stress, in a *hallucinatory* way returns, in *fantasy*, to a harmonious prenatal state of rest.

Ferenczi's claim that *perigenesis recapitulates phylogeny* (that the prenatal environment of the individual preserves the postnatal environment of its evolutionary forebears) is obviously a variant of the notion that *ontogeny recapitulates phylogeny* (that, in the maturation of any individual of the species, we find compacted all of the stages of its evolutionary development). There can be few theories more comprehensively refuted by twentieth-century advances in biology than this notion, Ernst Haeckel's 'recapitulation theory' or 'biogenetic law', routinely denounced as a product of pseudomorphism and wishful (and

3. Following a distinguished psychoanalytical tradition, Ferenczi talks exclusively about male sexual experience, with a characteristically Freudian promissory note that discussion of the female aspect of the problem must be postponed to a subsequent occasion (*Thalassa*, 18n1).

4. Ferenczi, *Thalassa*, 20.

sometimes downright contradictory) thinking. In Stephen Jay Gould's encyclo-paedic historical survey of the origins, uses and misuses of recapitulation theory, *Thalassa*, 'the boldest application of psychoanalysis that was ever attempted' according to Freud, trumps even the latter's lifelong devotion to Haeckel's biogenetic law and its flowering in his late speculative works.[5] Although rela-tively harmless compared to some of the dubious political causes into which recapitulationism was pressed, *Thalassa*'s egregious psychoanalytical fantasia holds pride of place for raising the theory to absurd speculative heights.

And indeed Ferenczi now goes further with the theme of amphimixis, con-necting the frictional movements of coitus with 'autotomy'—the mechanism by which certain animals can simply detach parts of their body, as a lizard leaves its tail behind when pursued. Phylogenetically, he argues, anal-urethral amphimixis can be traced back to a more fundamental conflict between a desire to physically detach (in order to cast off 'unpleasure') and a desire to retain organic unity—a kind of *archetypal itching*. Erection is incomplete autotomy, a 'striving to extrude' the unpleasure of tension from the body, enacted ludically in coitus and cut short by the vicarious 'detachment' of the sexual secretion.

This is not even like the old crude joke among men, apropos of *l'origine du monde*, that 'I was born from there and I've spent my entire adult life trying to get back there'; not even the idea that at the moment of orgasm the individual absents itself and returns to the circle of natural reproduction, becoming momen-tarily nothing but a member of the species. No, given Ferenczi's insistence on recapitulationalism, desire for the prenatal state is ultimately a yearning for the stage of evolution prior to the ascent onto land; in other words, the peculiar nature of coitus is understood ultimately as a repercussion of phylogenetic trauma. So the contention is that in coitus the intense investment of libidinal energy in the genital organ aims at *casting off* the itchy libidinal representative, which would symbolically swim back to the Precambrian, playing an executive managerial role by taking the whole organism's pent-up stress with it!

Thus is revealed the ultimate sense of a fourfold parallelism between evolutionary history, biological reproduction, physical individu-ation, and psychic fantasy life, as they momentarily enter into alignment.

5. S. J. Gould, *Ontogeny and Phylogeny* (Cambridge, MA: Belknap Press of Harvard University Press, 1977).

An overdetermination combines the hallucinatory return to the intrauterine situation and the replaying of the anxiety and rage generated at birth—psychic echoes of ontogenetic echoes of phylogenetic traumata. In pursuing an 'extremely general biological tendency which lures the organism to a return to the state of rest enjoyed before birth',[6] the organism at once finds a balm for its congenital woes...and ensures their perpetuity in its offspring. Through some ruse of evolutionary history, the phylogenetically-inherited frustration of being expelled from the beatific oceanic element is 'worked through' in the ontogenetic act!

What profit could there possibly be in attending to such an obsolete and frankly embarrassing theoretical misadventure? As I said, I'd like to draw attention to a theory of symbolism that Ferenczi sketches out in passing:

> Should our hypothesis some day be verified, it would in turn operate to clarify the mode of origin of symbols in general. Genuine symbols would then acquire the value of historic monuments, they would be the historical precursors of current modes of activity and memory vestiges to which one remains prone to regress physically and mentally.

A 'genuine symbol', then, is the product of neither imagination nor intellection, but a kind of encrypted artefact of material history. In insisting, remarkably, that 'the sea is not the symbol of the mother. The mother is a symbol of the sea', Ferenczi indicates a mechanism for the formation of symbols that doesn't pass primarily by way of human imagination: the link between symbol and symbolised is not secured by the interpretive mind; rather the symbolic relation and the interpreter capable of cognizing that relation are produced alongside each other as secondary symptoms or repercussions of another real relation. What is inaugurated here is the possibility of a naturalized account of the production of aesthetic relations wherein the human and its *aesthemes* are produced side by side. Non-cognitive responses to phenomena don't pass by way of the unfathomable depth of the subject nor by way of immaterial aesthetic essences.

This question might be clarified by comparing Ferenczi's with Kant's theory of symbolism: For Kant the symbol presents in experience, via analogy, something

6. *Thalassa.*, 19.

that is supersensible—*beyond experience*—yet which we must make use of (in an appropriately 'oriented' way) in order to make collective sense of our experience. Whereas for Ferenczi what is being evoked by the symbol is an *actual* experience—*albeit one that does not belong to 'me' except qua phylogenetic memory*. Thus Ferenczi does not stop at extending the biogenetic law into the thesis that *perigenesis recapitulates phylogeny*. Whereas for Kant reason determines the aesthetic as a relay of the idea, he suggests that biotrauma determines the idea as a relay of archaeoaesthesis—and therefore that *symbogeny recapitulates phylogeny*.

Here we are close to what Kielmeyer sought to construct: a 'threefold parallelism between geological or earth history, natural history or phylology, and human culture civilization and thought' whereby ideas are natural products that 'recapitulate, repeat, literally, the constitution or the organization of all these series in everything we do'.[7] Such a thesis (once again, a disreputable one) also reasserts itself in Deleuzian-Bergsonian 'universal sympathy', a 'florid vision' discussed by Christian Kerslake in his heterodox work on Deleuze,[8] and according to which evolutionary theory provides an account that both explains the apparently preternatural 'sympathy' of the denizens of the biosphere in terms of natural mechanisms, and at the same time reveals a process of phylogeny whose complexity precludes any straightforward recapitulation. Likewise, Daniel Barker states:

> Haeckel's widely discredited Recapitulation Thesis [...] is a theory compromised by its organicism, but its wholesale rejection was an overreaction. Ballard's response [in *The Drowned World*] is more productive and balanced, treating DNA as a transorganic memory-bank and the spine as a fossil record, without rigid onto-phylogenic correspondence. The mapping of spinal-levels onto neuronic time is *supple, episodic, and diagonalizing*. It concerns plexion between blocks of machinic transition, not strict isomorphic—or stratic—redundancy between

7. I. Hamilton Grant, in *Hydroplutonic Kernow* (Falmouth: Urbanomic, forthcoming 2015).

8. See C. Kerslake, 'Insects and Incest: From Bergson and Jung to Deleuze', http://www. multitudes.net/Insects-and-Incest-From-Bergson/. According to this Bergsonian-inspired theory even the predator in relation to its prey relies on a kind of mutual virtual inheritance, an 'inner history of nature', that allows it to enter into 'sympathy' with the prey so as to secure it, a type of intelligence which depends on a 'lived intuition' rather than a calculative judgment and which, as Kerslake argues, is assimilated to a dissociative somnambulistic state.

scales of chronological order. Mammal DNA contains latent fish-code (amongst many other things).[9]

If the unconscious is anything then it is a biological (and therefore evolutionary) unconscious, and immanent fish-memory perfumes human aesthetics.... The Deleuzian development of the notion of repetition evidently owes something to this same thought: 'it is true that our loves repeat our feelings for the mother, but the latter themselves repeat still other loves, *ones that we ourselves have not lived*'.[10] This is very much a Jungian inheritance. As Kerslake recalls, Jung talks about intuition in the human as 'the irruption into consciousness of an unconscious content, a sudden idea, or "hunch"', a process of 'unconscious perception' that owes precisely to this strange sympathetic community. The genius would be one who is able to loosen the strictures of organic specificity in order to move within this element of embryonic forces: to paint like a lion, or to dance like a lizard.... Éric Alliez amplifies this point in his discussion of the *virtualizing* labour of the painter, describing how Delacroix in his *Lion Hunt* undoes the partitioning of species through his attainment of an affective sympathy with the embryonic forces that shape Geoffroy de Saint-Hilaire's 'plane of composition'; a painting wherein all animate forms are essentially 'unformed and ambiguous beings', constituting a 'terrible community' that calls for a becoming-serpent of the painter....[11]

(A note on delirious method seems apt: for Ferenczi it is as much a matter of using the imaginary that emerges during analysis as a basis for 'decod[ing] the vast secrets of the developmental history of the species' as of enlightening ourselves on the meaning of said symbolism through recourse to natural history. In other words this is one of those singular points where psychoanalysis is indistinguishable from the delirium it treats—'As our teacher Freud has often repeated [...] it is certainly no disgrace if one goes astray in making such flights into the unknown').

9. Nick Land, 'Barker Speaks,' in *Fanged Noumena: Selected Writings 1987–2007* (Falmouth and New York: Urbanomic and Sequence Press, 2008), 501. Italics added.

10. G. Deleuze, *Masochism: Coldness and Cruelty*, trans. J. McNeil (New York: Zone Books, 1991), 87.

11. É. Alliez, *L'Oeil-Cerveau: Nouvelle Histoires de la peinture moderne* (Paris: Vrin, 2007), chapter 2.

There are a whole set of writings that extend the suggestion of this contagious, immemorial sympathy operating via the aesthetic. In Ballard, a given sensory environment might trigger virtual phylogenetic regression, the ultimate suggestion being perhaps that affective experience simply *is* nothing other than this: a transit within archaeopsychic space, triggered by aesthetic response (symbolic relations are routes back to real relations). But if, in traditional psychoanalytic terms, such a delirious method promises the wherewithal to put development on the right track to 'maturity', we should insist that this 'terrible community', must extend even beyond the contingent history of the biosphere, offering a space for a truly artificial aesthesis that experiments with unrealized portions of this virtuality.

Such a geotraumatics collapses the psychoanalytic account of trauma and repetition into the recapitulation thesis: one would recover lost memories not through a talking cure but by being immersed in the stimuli of a certain environment, just like Ballard's Kerans, or (the Proustian) Madeleine as she is led into the forest in Hitchcock's *Vertigo*. And whereas for psychoanalysis symptoms are memories of 'experiences' that the subject at the time could not 'experience', for geotraumatics aesthetic response is a matter of navigation within a memory bank of experiences that the subject never had, except insofar as he or she was produced alongside it as part of a broader and deeper memory.

This complex of ideas has also been interesting to me in reading Deleuze's early text, 'Desert Islands', in many ways the most enigmatic of his texts, where he speaks of the human as being the consciousness of the island. During this period Deleuze had an intense friendship with the novelist Michel Tournier, whose *Friday, or the Other Island* is a retelling of Robinson Crusoe, from a kind of Jungian perspective, where the protagonist ends up melting into the island, becoming a part of its larger organism.

It is—quite evidently!—impossible in such a short time to extract the kernel of conceptual insight here from its entertaining yet egregiously pseudoscientific husk, and to reconstruct it in suitably 'supple and diagonalizing' form. I would merely insist that any discourse on aesthetics that doesn't involve itself in decrypting human experience down to at least premammalian strata can only be a quaint parochial addressing protocol; it remains superficial in the sense that it's stuck at the stage where the geologist might name a geological stratum 'Devonian'....

By the same token, though, if (notwithstanding the importance of neoteny, and the contributions of the memories formed in a human lifetime) aesthetic experience is fundamentally archaeophanic, this doesn't guarantee that any device or trigger would promptly and neatly draw to the surface some particular stratum. We are talking about cryptography here (*supple, episodic and diagonalizing*—remembering also that Freud's very first theory of hysteria clothes itself in the language of both cryptography and geology, simultaneously disavowing them as mere rhetorical devices). And yet such strong alignments are perhaps not impossible.

Now, I used the word *aesthemes*, enduring components of human aesthetic experience (what Ferenczi calls 'true symbols') whose deep resonance and transcendent qualities—in marketing and advertising as well as in the visual arts—make appeal to a transcendent self which, through sensory experience, is intimately touched by ideas that are equally transcendent. (The blue of a painting can become the blue of the sky and then a transcendent blue symbolising freedom, only to a soul capable of sensing blue and of thinking freedom.) The transcendence of the subject is reproduced or affirmed at the same time as the transcendence of an aesthetic essence beyond any particular material instantiation. But this beyondness and this transcendence in fact should, in a moment of 'descendentalism' (to use Iain Hamilton Grant's word) be referred instead to the vast memory system I just spoke about.

And what about an art that blocked this mirroring relation? One dimension of Swiss artist Pamela Rosenkranz's work seems precisely to involve addressing certain inherited aesthemes (the play of light on water, skin colour, the colour blue)[12] not by symptomatically repeating their gestures (reproduction and epidemic), but also not by simply refusing them (the phantasm of a *conceptuality* entirely uncontaminated by the aesthetic—which Rosenkranz's work on Yves Klein problematizes nicely).

What really struck me in her work—and I spent a long time trying to explain over and over again to myself what it is that was going on—is a kind of formal congelation of these aesthemes. When they are made to appear

12. See P. Rosenkranz, *No Core* (Zurich: JRP Ringier, 2012), which contains a more extensive essay by myself, and one by Reza Negarestani focusing in particular on the question of the evolutionary provenance of blue as aestheme.

in opaque, objectal form, they're no longer able to do this mirroring, this transcendent reflection, but instead appear *as* objects—or, better, *products*. For Rosenkranz's work is also concerned with how capitalism, while on one hand certainly making use of the transcendence of aesthemes, tends on the other hand, operationally, to automatically depose them through its unsentimental isolation, machinic abstraction, intensification and mass-production.

In the series 'Firm Being' (2009) Rosenkranz takes plastic water bottles and, in a gross reification of symbolic matter, fills them instead with the silicone product Dragon Skin, intended as a prosthetic double for human skin. This exemplifies the artist's use of a palette of readymade aesthemes in such a way as to strip them of their semantic transparency. We no longer find in this bloc of skin tone the luminous essence corresponding to our internal depth; and the product's promise to impregnate us with that indefinable something instead becomes opaque and troubling.

But this does not assume an 'elimination' of aesthetic effect. It's instead to do with a treatment that (in the Laruellian sense) *reduces its sufficiency*. It's this method of *blocking* that is really interesting to me. This refusal produces a new kind of object. It's something like how Laruelle describes his practice, in terms of the use of philosophy as a *material* in order to produce something else. As he rightly says, the only way to do that is to *prepare* the material by looking at it from the point of view of this kind of sideways causality: the aesthetic relation is produced alongside the apparatus of aesthesis.

If I were to talk about this as a 'non-art', I would want to distinguish it from the art-history of various 'non-arts' which have been one kind of negation or another—just as Laruelle wants to distinguish his non-philosophy from the perpetual attempts of philosophy to escape itself. It would be a kind of non-standard expansion of the domain of the aesthetic in which aesthetic materials (aesthemes) are acknowledged and utilised but their sufficiency reduced, Crucially, in doing so, some other kind of experience occurs in which, rather than being subject to the perennial passions of the aesthetic, we enter a context that challenges our 'being prone to regression', that scrambles memory, concept, and sensation, triggering new responses that call up synthetic memories of the future which, for the moment, we have no words to describe.

Ben Woodard

Uncomfortable Aesthetics

The relation between aesthetics and nature, broadly construed, appears doubly overdetermined. Firstly by the (now largely abandoned) discussion of the sublime and the lingering phantoms of thinking nature aesthetically in terms of the picturesque, the untouched and the pristine which followed the degradation of the sublime. And secondly, by an intertwined set of artistic practices that have emphasised the attempt to avoid the use of nature as fodder for art (and other material practices). I will attempt to trace this bifurcatory map of nature and aesthetics as it recapitulates the temporal derivation of aesthetics from nature. F.W.J. von Schelling's thought, I will argue, allows for a concept of artistic practice that indexes nature's formalized productivity without being determined by it.

The sublime can be understood as an instance of human nature as seen from afar, the picturesque an instance of being too close to nature as human. These tactics are discussed by Timothy Morton in terms of 'critical distance' and 'framing', though I wish to enact an implicit critique of the object-oriented philosophy he draws upon as I proceed. Problematically, the two relations of distance and framing feed into one another. The fundamental tactic of the Kantian sublime is to wire the towering tidal wave, together with the flowing lava, back into the powerful finitude of the subject as observer, based on that minimal distancing. Framing, on the other hand, begins from a more surefooted subject; it takes the world as a problem which we pass through in order to come back to our own capacities—not to solve the problem, but to revel in our own finitude.[1]

An essential question then: What would an ecologically focused speculative aesthetics be, other than a redoubling or exacerbation of this oscillation? The obvious response, it would seem, would be to either reinstate the Kantian sublime but orient it toward transcendental realism by moving the split of sense regarding space from the subject to the object. Or else to restructure our interaction with nature in order to seriously reconsider all material production as having a

1. See T. Morton, *Ecology Without Nature: Rethinking Environmental Aesthetics* (Cambridge, MA: Harvard, University Press, 2009).

real irreparable cost; i.e. to reverse framing so as to constantly be framing our action according to nature, always attempting to determine our speculative yet real or deromanticized finitude.

One pressing problem is that these possibilities have already been papered over by more affordable (and aesthetically overdetermined) versions: The absorption of the sublime via a transcendental realism is preempted aesthetically by the fantasies of eco-catastro-porn. And on the other hand, critical material production is easily buried in what I call a 'cute' ecology. In the former, nature exceeds our grasp but only through our staging of the fantasy of ecological collapse. The absolutely huge and absolutely destructive, or more precisely purportedly *unmappable* complexity of ecological disaster seems to be simultaneously a mathematical and dynamical sublime. Yet these fantasies maintain a split between the world and earth, as the end of the world allows for another to emerge, one that invariably begins under the auspices of utopia. Cute ecology, on the other hand, relates to but surpasses the aesthetics of 'greenwashing' capital which, by urging superficial changes to consumption practices, aims to make capitalism compatible with ecology (very much in line with Žižek's 'capitalism with a human face'). Our regular, or even increased, purchases guarantee some amount of ecological stability in another part of the world, but a stability only in so far as it is representable to us. As opposed to the tacit passivity of catastro-porn, cute ecology allows for a more proactive posture, in that it allows individuals to get upset and to take (economic) action to protect particular species or landscapes they find aesthetically appealing.

In both eco-catastrophics and cute ecology, the tension between local and global is paramount, but serves primarily to reinscribe the incapacity of the human, in the wake of the sublime, to do anything other than vicariously experience it and then pass it off to preexisting governmental or capitalist safety nets. This massive global level stands in contradistinction to the atomized consumer, who can only view themselves, and even large organizations, as incapable of addressing any aspect of ecological crisis, never mind ecological crisis as a whole. This in turn leads to the abandonment of large-scale conceptual schemas: What could the terms 'nature' or 'ecology' mean, given the ineffectuality of ecological intervention? Furthermore, since these interventions evidently bind us to capitalist practices, we either doubt the potential of developing truly green

technologies because of the bottom line, or simply dismiss designed technological solutions (as in the anti-technoscience attitude often found within 'Continental' philosophical thought).

As for cute ecology, Morton has argued that cute animals bring a dangerous sentimentality to ethics and create obstacles to thinking ecologically. However he still seems to think that there is some use for the cute as opposed to an 'into the wild' mentality. Morton argues that it is the barrier between the cute and non-cute that needs to be removed—but how could this ever be possible? While renegotiating the conceptual bulwark of nature's aesthetics is problematic enough, cuteness goes far beyond the aesthetics of nature. A cute ecology has strange consequences for environmental aesthetics, as for example when endangered animals are chosen to be taken to zoos for preservation only if they can attract sufficient revenue. Cuteness determines the cultural capital of animals, and endangered species in particular. The problem for any speculative aesthetics of nature is that this kind of affectivity comes at the price of epistemology. The problematic aesthetic of cuteness can be further articulated following Magnani's use of Gibson's concept of affordance: affordance is defined as the action potential of part of the environment in relation to the perception of the individual. This is discussed by Magnani in terms of ecologically rooted chances.[2] In Magnani, perception is understood as an act, not a reaction between agent and environment. In this sense, the manipulative nature of cuteness can be interpreted as the technological extension of the hardwired disposition to be protective of the features of the young—paedomorphism across species lines (which sounds worse than it is!).

In comparison to the multiple shifts of perspective Kant must perform to justify the appreciation of the sublime, the cute appears as an asymmetrical acceleration of the aesthetic fascination of our own potential as gene carriers. Cuteness is an asymptotic poison flowing out across every form of aesthetic mediation. Yet cuteness points, in however warped a way, to the material potential of nature, constricted as it is in our being of our species. In cute ecology, design asymmetrically synthesizes ecocatastrophics; as such, it is the best means of overturning an ecological aesthetics trapped in the double-bind described

2. L. Magnani, *Abductive Cognition: The Epistemological and Eco-Cognitive Dimensions of Hypothetical Reasoning* (Berlin: Springer, 2010).

above, without challenging the naturalness of our concepts of nature or being increasingly divorced from our interaction with nature (whatever that means) and the forms of thought stemming from it. Ecological design attempts to be hypermodern on the outside while eco-friendly on the inside, which indicates a return to a naturalness; a stability made of fantastic nature but without material nature. As recent discussions with Simone Ferracina[3] make clear, the trick becomes how to sell uncomfortable design that erodes the packaged stability of nature-as-home. But how can you unbind sedimented desires from each of the articulations of renewal—one global, one local, though each points to its other: the cleaning of the earth for ecocatastrophics, the saccharine promise of new life for cute ecology?

Our purported distance from nature and its opposed framing assumes a prior nature-thinker distinction, a distinction internal to thinking but one that is illuminated by Schelling. Following his reading of Kant's methodology, which reinstates the problems of representation, Schelling identifies a problem complicated by a nature, which is not prethinkable. This nature is a complex of dynamic forces that creates in spite of itself an identity of spacetime which, in trying to rip itself to pieces, produces actualities as well as nature's continuum of movement. Taken up by human minds, movement engenders productive computation and intuition through embodiment, and is translated in the transcendental as a timing and spacing out of thoughts on construction. Given such a nature, design becomes a form of auto-manipulation where the production of objects warps our own concepts of nature while also requiring the reduction of nature to manipulable materials in order to think design as such.

Here one can see the ecological benefits of Schelling's claim that the plastic arts represent nothingness as inexistent as opposed to impossible or otherworldly. Designed objects seek to materially embody new forms that can capture at once nature's forming of us and our forming of nature. Usually treated as the transcendental side of the equation, the creation (or perhaps more accurately discovery) of form suggests the capacity of new objects to produce new methodologies or new fictions, the possibility of manipulating concepts so as to assist in the production of the actual. Ecology requires an aesthetics of manipulation that

3. See http://simoneferracina.com/.

emphasises the razorblades of contingency over the fantasy of catastrophe and
the futurity of cuteness (or maybe the cuteness of futurity).

But here another bifurcation arises, that between the creation of norms
or productive fictions and the production of manipulative objects. The sinew
between them is a realist philosophy of nature, a nature that forces thought
into a moving production of itself, within nature's entropic tendency towards
self-rendering, towards restless proliferation—with the caveat that we depend
on the actual in a way nature does not.

Discussion

SIMON O'SULLIVAN: I've got a question for Robin, but I think it might be going to Mark as well. Robin, one of the things that strikes me, and it's a bit like what I was saying to Tom, is that one can have the 'aestheme', but it's kind of an evacuation of the human, and yet, whether it's a story by Ballard or a Smithson, it's all human. And so that seems to be a real issue, that while aesthemes evacuate the human from these things, yet the human comes in as the person reading the fiction or the person who wrote it.

If I remember rightly, *Friday* is a story where Robinson goes through this series of rituals and practices and performances, as you know with the goats in the trees, and he buries himself in the island, doesn't he? He does all these various practices in order to save the island. And it strikes me that there's something really interesting about that practice that's not a million miles away from what you were saying, Mark, in terms of schizoanalysis and counter-engineering. That it's not so much a practice in the sense of an art practice that's 'about' something, about depicting something; it's a series of practices or rituals or performances that allow transformations to take place.

There are two questions here really: one is about aesthemes and the way the human comes back in; but the broader question is whether bringing art and speculative realism together is more interesting if we think of it in terms of practices that themselves allow one to become different, to step 'outside', etc.

ROBIN MACKAY: Of course art is made by humans for other humans to experience. The notion of the aestheme doesn't at all try to evacuate the human; that's why I think it's interesting. If we take an aestheme, cuteness would be one, the sublime would be one. What are they? They're relations between certain material objects and certain ideas, and the traditional way in which we think of them is to understand the idea as belonging to a transcendental subject and the aesthetic qualities somehow to exist in a purified form elsewhere, beyond the particular object in which they are presented. What's interesting for me in what I would call the 'sideways causality' at work in Ferenczi is that the relation itself does not constitute the aestheme; the aestheme can be said to exist

independently of it. So it's not really a case of evacuating the human, but it's a case of conceptualising the aestheme in a different way, in which one's invest-ment in it shifts and the subject is actually transformed. And this is particularly interesting in relation to the sublime, because as people have always noticed, it's really difficult to write about the sublime, a sublime painting, say, without writing in a sublime way. It's difficult not to propagate it, one is indeed 'prone'—and this propagation is indeed a question of ritual. And I think this kind of blocking procedure is a genuinely interesting way in which to break from this epidemic dimension of art in a new way, by presenting these things in a 'desufficient' form. Presenting them in this different way, rather than separating ourselves from them or trying to leap outside of or beyond them—not to try and jump outside *again*, but to take a perspective in which we are already outside the circle.

MARK FISHER: This is the crucial issue for me, this question of leaping outside; this came up this morning as well, leaping too quickly over the subject, over the human, etc. We can see the CCRU, early Land etc., as being haunted by this problem, I think. It is as if the argument is: If the real isn't human in some sense, then everything about being a human is total illusion. Okay, that might be true, but then so what? Things would carry on anyway. I think there was a kind of struggle as to what kind of practice would link the two; and I think it ended up in a kind of self-hatred, because it *couldn't* be writing, that wasn't good enough, that was just a relation of transcendence and not what will actually take us out of being a human.... But if we see writing as a practice, which of course it is, things look different.

At the same time, what is called lived experience is a product of ideology, which is fundamentally ritualistic—it is not first of all ideas, but behaviours. Which is just to say that I think the way out of this bind is to do what they say in pedagogical practice and to start where people are, as it were. That we are here now, but whatever it is that constitutes the 'for us' is mutable, is subject to change.

So, I think the link then between the philosophical project of eliminativism and actual cultural practice, I think that's the key. It might well be true that, as Metzinger says, there's no self, but selves persist, as ritualised performances, and this has a clear aesthetic dimension.

So maybe here the role of the aesthetic would be much stronger than that of theory. And maybe the role of the aesthetic is to culturally propagate things, so as to interrupt the ritualistic reiteration of a subjectivity which may well be pure simulation, but nevertheless is highly effective.

RM: The most amusing thing about the 'performative' aspect of Laruelle, and the reason why his writings really annoy people is that they are nonplussed by the fact that he says he's doing non-philosophy, but then how come his writing isn't like some kind of crazy beat poetry, how come it still looks like, and uses, philosophy? That's what really annoys people: that he's continuing to practice and do something and yet he's claiming this kind of indifference. Similarly, in conversations I've had with people about Pamela's work, some people find it just impossible to engage with and I believe it has to do also with this kind of *blocking*, this refusal to mirror. And yet obviously it's in art galleries, and it's in the institution, and it is artwork. So yes, it's more interesting to actually practice rather than get obsessed about this immanentization question; but to think seriously about how to practice otherwise.

AMANDA BEECH: Because we know that this rhetoric of escape, this desire to escape the paradigm that we know is art, is very much a kind of standard politics of resistance that requires a relation to what is resisted. You know, its negation produces a relation. But Robin, what you're describing is I think something like a non-relational resistance of some kind, and I find that compelling.

But then I think also, what kind of relations are being formed and grasped here? If we're not thinking about a relation with what is being resisted, what are we producing in terms of new forms? Is it reengaging its own history, the history of art for example? If so, what is being affirmed in those connections and the interpretations that are going on in a practice? What is being grasped as a relation, and why?

That leads me to pick up on your question of future and past, Ray. This question about the future is really important here, because what is it we are grasping in the non-relation? I am a little anxious that, if we can't perfect a non-relational

resistance, we might end up with some reinvention of autonomy for art and a remystification of the aporia of the aesthetic and those kinds of dynamics.

So this question of islands is interesting in its resistant form, but it also promises something like shamanistic autonomy for the image and that worries me, because that would be to suppose a discrete territory without purpose, if you like. But this seems to me to be the primary mode in which art aids and abets capital and produces it, and that's the art that we love as capitalists. So while on the one hand it's claimed as being deeply politicised because of its separateness if you like, its resistant form, that, as we also know, is the very form around which we pivot our relations in terms of capitalist accumulation. So I guess those two figures that I'm identifying here seem to be close but very different in many ways as well.

PETER WOLFENDALE: I thought I'd try and pick up on what Mark was saying about art after experience. I get what you meant with the relationship between Hume and Kant, and how this figures a lot of stuff. And I thought it'd be interesting just to pick up what seems to be one of Kant's crucial insights: the fact that for him the experience of beauty and the experience of the sublime, these things that are subjectively universal, they're cognitive, fundamentally cognitive in a way that, say, having a nice meal, that's like 'mmm, tasty', just isn't. So that's the difference between aesthetic judgements of taste and aesthetic judgements of the beautiful and the sublime. And I think this can lead you into an interesting open space for getting past phenomenological conceptions of art. If we start having this more complicated understanding of social cognition, then we have to start talking about cognitive systems, sociocognitive systems like collective agents and other kinds of mechanisms which simply have no phenomenology. In what sense does a group form themselves as a collective agent that has an artistic experience? Well, if there's cognition, there's some sense in which there might be some sort of artistic relationship; but it couldn't possibly be described in any phenomenological terms.

MF: I think my problem here is that it's still like rushing too quickly out of the human. You have to pass *through* the phenomenological in a certain way in order to attain the cognitive response. I don't mean you have to stay at the

phenomenological, of course, and I think that there are ways of getting beyond
that. One is the extent to which the cognitive is always implicated in the
phenomenological anyway, which is already there in Kant; and secondly, what
cognitive judgements do particular phenomenological manifestations mandate
or call up? But this is much more than the idea that you can just rule out the
phenomenological entirely or that we can just leap over it to a purely cognitive
account of art or whatever; that seems to me just going nowhere really.

RAY BRASSIER: I totally agree. Kant transforms the account of experience
into one of cognitive experience—it becomes experience as a cognitive
accomplishment, because experiences can be structured through judge-
ment and through conceptual synthesis. So I think the point at which they
manifest, some phenomenal level, some stratum of phenomenal experience,
is indispensable. It's possible to embrace it as a post-Kantian conception
of phenomenology, which is that phenomenal experiences are conceptu-
ally mediated and propositionally structured in some complicated sense, as
opposed to a more problematic sense of the term, which would say that the
world has this predetermined categorical structure. So I completely agree.
I mean, you can't get beyond the empirical; the manifest is indispensable. But
the point is a dialectic between the phenomenal and the noumenal such that
the possibilities of experience, of perceptual experience, are enlarged through
conceptual, through cognitive revolution; so aesthetic experience in that sense
is something that is an enlargement, an expansion of the horizon of perception.
Aesthetic experience in that sense is indispensable and illuminable because it
is perceiving things that transcend any merely sensible synthesis. So I'm just
reiterating this point—this is why you cannot leap over the manifest image.

MF: Isn't that the danger of wanting to go beyond Kant, into transcendental
materialism?

RB: The boundary between the phenomenal and the noumenal is constantly
renegotiated. And the point is that there are no phenomena without noumena,
and the noumenon is the reality of the phenomenon. It's something that is
embedded in the structure of the phenomenon. So, in other words, phenomena

are real. This is Kant's point; they're not illusions. Phenomena, shadows, are real. But to understand how phenomenal experiences are dimensional projections of a higher-dimensional reality is a cognitive task. And then the point about the cognitive is that you can enlarge it: we perceive things that were imperceptible several centuries ago.

MF: Isn't that then Kant instead of phenomenology? Schematically, we can divide this post-Kantian account of phenomena from these dominant neo-Humean models of phenomenology and also much of Deleuze, where you've got this idea of autonomous sensation. But we can perhaps see the whole schizoanalytic project as much more to do with the former, as a reengagement with Kant over the question of conditions of experience, which are now seen as mutable rather than fixed. But the idea of sensation, accessible without conditions of experience of any kind, isn't that a kind of Humean temptation in Deleuze's work?

RB: I think it's also a legacy of Bergson. Bergson is the real culprit, Phenomenology in the early Husserl and Heidegger is about the inapparent within appearances. It's not just describing what things seem like, or what they could feel like. But the problematic claim of Bergson is that there is this dimension of absolute individual experience, there's this absolute dimension you can *intuit*. There's a point where thinking and feeling fuse, and what you find in Bergson is the idea of recovering this sub-representational, sub-conceptual stratum of experience, which is always individual.

This is tied to an attack on the sociality of human perceptual experience. The gregarious self is a merely superficial crust hiding this deeper, more profound individual. Whereas Kant's point is that what makes you a subject of experience is the fact that when you have an experience, you're having an experience that could be had by any human. This is the difference between *Erfahrung* and *Erlebnis* in German philosophy; *Erfahrung* is cognitive experience which is necessarily social and collective; *Erlebnis* is lived experience which is supposedly private and inter-subjectively effable. And that's problematic, since it's that model of experience as *Erlebnis* that has become potentially capitalist idealogy, the idea that what you feel and what you directly experience is this inalienable fulcrum for everything else.

RM: Very schematically: art has always dealt with images of the real, and at one time maybe there was a belief that there were 'good' and 'bad' images of the real, and now we're in this position where it seems (as Amanda was saying) that we worry that there are only 'bad' images, since representation itself is somehow inherently ideologically tainted; and yet we still have to go through them. This is the variously tragic, ironic, or self-satisfied predicament. But why does that peculiarly moral judgement have such a hold? I wonder whether we could instead talk about images as being models of the real, or fictions; fictions in the sense in which Laruelle uses the term, Or low-dimensional projections, as Ray was saying. To think about this in terms of models and what they do, what they allow us to do in the real world, is to learn a lesson in Copernicanism. 'We cannot escape mediation through a form of images, but images are evil'—This is just a form of narcissism, whether you're bemoaning it or whether you're celebrating it as a correlationist.

MF: But haven't you just evacuated aesthetics there, in the sense of what is specifically aesthetic? You could have models that have no aesthetics whatsoever. That would be my problem.

RM: That would be intellectual intuition, surely?

MF: Yes, but the point is that given that you're thinning down the aesthetic content by doing that.

ALEX WILLIAMS: Why would you necessarily want to do that to models? Thin down the aesthetic content? I don't know why you'd want to. Because that aesthetic content may be vital in enabling you to gain traction.

RM: Yes, surely it's the compelling nature of the aesthetic content that makes a model effective, as well as its purchase on the real or, if you prefer, its capacity to further abstraction and therefore action. It comes back again to the notion of cunning, and methods. And that's all about being in the middle of models and their powers, and not having an absolute viewpoint; it's about, very literally, putting yourself in another's place, not sentimentally but through prosthetic

use of 'aesthetic technologies'; and thus refusing to accept that you're trapped forever in one reality, one set of rituals, along with their attendant abstractions.

AW: I was thinking about what Amanda was talking about, this question of relations and the potential political content of aesthetic forms. So, there's this idea that says that resistance is bad because it ends up regenerating the thing you're trying to get away from; on the other hand we get this sort of subtractive or non-relation which you were pointing towards, Robin, to some extent, with Laruelle. I think that Amanda also raised this idea of the realist engagement with a future, and this is something that I think might provide another kind of way out of this nightmare whereby all left politics get turned into a politics of resistance, which, as Ray was saying, is basically a reactionary politics of fear, with a reactionary imagination. And maybe to move outside of this situation where we're obsessed with this thing we can't get away from, where the best we can do is to create a vacuole that is effective temporarily, to reengage the future and therefore generate something on that basis—this would be a speculative aesthetics. With Landian accelerationism there is certainly a suggestion that it is through aesthetics and through aesthetic representations and experiences, through thinking from the standpoint of this future, that you can generate that future.

MF: But the problem with that was that the future had already happened, so all you could do was get on board with it or not; and that produced a kind of self-hating impotence, actually: It doesn't matter, Kapital, the Terminator, has already happened and we're just this sad relic waiting around for termination, cheerleading along, and the Terminator will show no more mercy to us than those who decide to sit around campfires, hymning the natural beauty of the earth or whatever. But what's hinted at sometimes in those texts is that the future will only happen if it's made to happen *now,* so that gives you a positive immanence rather than an impotent negative transcendence.

I just want to come back to the broader themes that have come up today, this relationship between purposiveness and non-purposiveness, etc. I think what also relates to this is that the Landian ideology of that moment did fit with neoliberalism in that it was the idea that control and organisation are inherently

oppressive. Whereas I think with Alex and Nick's accelerationism, there can be a role for management and control where, rather than inhibiting a certain kind of acceleration, it can intensify it, raising this question of aims and ends. And I think also the important point about the supererogatory is that there can only be a supererogatory excess when you do have a determined aim. If you don't have any aim or lure, then you don't get any excess. And I think this points to a crisis of 'experimental™' culture, which has no real experiment in it because there's no concept of success or failure. There's no real aim, the form is negatively defined in relation to the non-experimental. There's nothing taking place in these experiments; you're not finding anything out.

That's one thing that's come out for me really strongly today, is that dialectic between aim and a purpose and purposiveness of a certain kind. Genuine experimental practice would have specific determinate aims, that's how you open up things into an unknown.

Notes on Contributors

AMANDA BEECH is an artist and writer whose work proposes a new realist politics of the artwork and its possibilities in the context of contingency. She is Dean of Critical Studies at California Institute of the Arts.

RAY BRASSIER is Associate Professor of Philosophy at the American University of Beirut. He is currently working on a book about the American philosopher Wilfrid Sellars, entitled *Reasons, Patterns, and Processes: Sellars' Transcendental Naturalism.*

MARK FISHER is the author of *Capitalist Realism* and *Ghosts Of My Life: Writings on Depression, Hauntology and Lost Futures* (both published by Zero books). He is the Programme Leader of the MA in Aural and Visual Cultures at Goldsmiths, University of London.

ROBIN MACKAY is Director of Urbanomic and editor of *Collapse: Journal of Philosophical Research and Development.*

LUKE PENDRELL is an artist and writer based at the University of Brighton. His work, which explores the interstices of science, technology and the supernatural, has been exhibited at The Barbican, London; MoMi, New York; and Le Salle de Legion d'honneur, Paris, amongst others.

BENEDICT SINGLETON is a strategist with a background in design and philosophy. He is based in London, where he divides his time between consultancy work, self-directed and pro bono projects, and running a graduate architecture studio at the Royal College of Art.

NICK SRNICEK is a Teaching Fellow in Geopolitics and Globalisation at UCL. He is the author, with Alex Williams, of *Inventing the Future: Folk Politics and the Left* (London: Verso, forthcoming 2015), and the editor, with Levi Bryant and Graham Harman, of *The Speculative Turn* (Melbourne: re.press, 2010).

JAMES TRAFFORD is Senior Lecturer in cultural theory at University for the Creative Arts, Epsom. He works primarily on the intersections of rationalism, non-standard logic and mathematics.

TOM TREVATT is a London based writer, lecturer, curator and PhD candidate at Goldsmiths University of London. He is an Associate Lecturer at Goldsmiths, The Bartlett and University for the Creative Arts. His research revolves around the intersection of neoliberal politics and economics, the environmental impact of fossil fuels and contemporary art.

ALEX WILLIAMS is currently completing a PhD thesis entitled *Complexity and Hegemony* in the politics department of the University of East London. He is the author, with Nick Srnicek, of the forthcoming *Inventing the Future: Folk Politics and the Left* (London: Verso, forthcoming 2015).

BEN WOODARD is a PhD student in theory and criticism at University of Western Ontario. His work focuses on naturalism in the thought of F.W.J. von Schelling.

The editors would like to thank The Artworkers' Guild, University for the Creative Arts, the participants and audience of the roundtable discussion, and Linda Stupart for transcribing the day's proceedings.